Life

The birthplace of Leonardo has for many years been a matter of speculation. It is generally thought that he was born at Anchiano, just outside Vinci, but some historians believe, on insufficient evidence, that he was born in Florence. Most probably he was born in the town of Vinci in 1452, the illegitimate son of Ser Piero, a notary, and of Caterina, the wife of Acattabriga di Piero del Vacca da Vinci. The legends handed down to us by his biographers, the Anonimo Gaddiano and Vasari, are products of the aura of myth which surrounds the circumstances of his birth. A document dated 1467 refers to Leonardo as one of the dependants of Ser Piero, and in the same year he joined Verrocchio's studio. In the following year he became a member of the Guild of Painters and seems also to have attended the studio of the Pollaiolo brothers. The entry in the *Libro rosso dei Debitori e Creditori* (Red Book of Debtors and Creditors) of the Guild of Painters is dated 1472. Leonardo's first dated work is the *Landscape Drawing* in the Uffizi, dated 1473. Legal documents dated 1476 relating to Leonardo's arrest for homosexual offences in a public place provide evidence that he was then still at Verrocchio's studio. It was about that time that he was given permission by Lorenzo de' Medici to work in the *orto mediceo* (the Medici garden) in the Piazza San Marco, Florence.

In January 1478 Leonardo was commissioned to paint a panel in the San Bernardo Chapel of the Palazzo Vecchio. This commission had previously been granted to the Pollaiuolo brothers. However, for reasons unknown, Leonardo did not complete the work. In the same year he executed a painting of the *Two Marys,* now lost, and made a drawing depicting *Bernardo Bandini Hanged* after the Pazzi Conspiracy (Bayonne Museum). Records dated 1478 no longer include Leonardo's name among his father's dependants. In 1481 he signed a contract with the monks of San Donato a Scopeto, near Florence, for an altarpiece *Adoration of the Magi*; this unfinished painting is now in the Uffizi.

According to Vasari, the *Portrait of Ginevra de' Benci* was painted at this time. It was at her father's house that Vasari saw the *Adoration of the Magi*. In the same year Leonardo painted the *St Jerome,* now in the Vatican. It was at this time that Leonardo's interest in science and experimentation first became evident. In the Medici circle experiments were carried out based on the mathematical theories of Pythagoras and Leonardo adopted these theories as his own and made them the basis for his own scientific investigations.

For reasons which are still unclear, Leonardo became anxious to leave Florence around the year 1480, and he wrote a letter to Lodovico il Moro (*Codex Atlanticus,* p. 391) asking to be admitted to his service as an engineer or artist. On 25 April 1483 Leonardo was in Milan, and in the same year he signed a contract with Evangelista and Ambrogio de Predis, undertaking to paint *The Virgin of the Rocks* for the monks of the Monastery of the Conception at Porta Vercellina; the painting was delivered in 1490. Leonardo now began his research into aerodynamics and submarine navigation and planned the dome of Milan Cathedral. He worked on this from 1478 until 1490, the year in which he went to Pavia to prepare plans for the alterations to the cathedral and castle there. In 1489 Lodovico il Moro commissioned Leonardo to produce a colossal equestrian statue in memory of Francesco Sforza, Lodovico's father. Though Leonardo occupied himself with this project for very many years, he got no further than making a clay model of the horse, which was destroyed in 1501. At about this time, he began work on the *Last Supper* in the refectory of the Monastery of Santa Maria delle Grazie in Milan. In 1495 he was summoned to Florence to advise, together with Sangallo, Michelangelo, Baccio d'Agnolo and Cronaca, on the construction of the great hall of the Palazzo della Signoria. On his return to Milan, later in the same year, he began work on the decorations for the *Camerini* in the Castello Sforzesco, and in 1498 he decorated the Saletta Negra and the Sala delle Asse. Together with his close friend Luca Pacioli he delved further into mathematics and geometry. The portrait he painted of Count Sforza's mistress,

Lucrezia Crivelli, did something to improve his poor financial position.

On 26 April 1499, Il Moro presented Leonardo with a vineyard near Porta Vercellina, but the Duke's situation was precarious and in 1499 Milan was occupied by Louis XII of France. Leonardo went to Venice with Luca Pacioli and entered the service of the Venetian Republic. His task was to prepare defences to withstand the Turkish advance on the Isonzo. In 1500 he settled in Florence and executed the *St Anne* cartoon. The monks of the Monastery of the Annunciation had asked Filippino Lippi to untertake this work, and he passed it on to Leonardo. But Leonardo was producing only a few paintings at this time. His main preoccupations were his mathematical research and the construction of the defences for Duke Valentino's fortresses in the Romagna; in 1502 he was appointed military engineer to the Duke. In 1503 Leonardo, again documented as a member of the Guild of Florentine Painters, was commissioned by the Signoria to paint the *Battle of Anghiari* in the great council chamber of the Palazzo Vecchio. He made cartoons for this work, studied new techniques for transferring them to the wall, and designed special scaffolding, but the project was soon abandoned. In the same period he painted his portrait of Monna Lisa del Giocondo (the *Mona Lisa*, completed in 1507). Leonardo then dedicated himself body and soul to his experiments in aerodynamics and designed a machine in which he intended to take off from Monte Ceceri, near Fiesole, and fly over Florence.

In 1506 Leonardo was recalled to Milan by Charles d'Amboise. Here he entered into relations with the French and made studies for a monument to the city's governor, Trivulzio. In 1507 the King of France appointed him his *peintre et ingénieur ordinaire,* and Leonardo began to plan the construction of the Adda Canal basin. In the same year he moved back to Florence, probably starting his treatise on hydraulics (*Trattato di idraulica,* Leicester Codex). He continued these studies on his return to Milan and in 1513 he completed the construction of the Adda and Martesana Canals. He then worked intensively on problems of anatomy, meteorology, astronomy and cosmography. In 1513 he

left Milan and went to Rome, where he entered the service of Giuliano de' Medici, brother of Pope Leo X. In Rome Leonardo executed paintings which are now lost, made plans for draining the Pontine marshes, carried out important geographical research and began his treatise on the art of painting (*Trattato della Pittura*). When Giuliano died in 1516, and a task which Leonardo had long desired to undertake – the construction of the façade of San Lorenzo in Florence – was entrusted by the Pope to Michelangelo, he decided to accept the invitation of Francis I and move to France. He left in the same year, 1516, and settled in Cloux, near Amboise, in 1517. His work in France was mainly of a philosophical and scientific nature; he was old and paralysed in his right hand. He also devoted himself to teaching his favourite pupil, Francesco de' Melzi, to whom he dictated his will on 19 April 1519; on 2 May of the same year Leonardo died. He was buried in the monastery of Saint-Florentin, Amboise. By the latter half of the eighteenth century no trace remained of his grave.

He bequeathed to Melzi a large number of notes and notebooks, not all of which have come down to us. There are nineteen notebooks of which we have direct knowledge, containing 3,500 pages filled with sketches and notes on both sides. In addition, many single sheets are scattered through various museums. The *Codex Atlanticus,* now in the Biblioteca Ambrosiana, Milan, is a collection of some of these sheets.

Works

Largely thanks to Vasari, Leonardo's early years long remained in the realm of legend, and even the ablest historians were loath to attempt either to reconstruct Leonardo's early activity through the works which can be assigned to those years or to fit this activity into the framework of late fifteenth-century Florentine culture. Vasari embroidered the history of Leonardo's life until it bordered on the miraculous, and for many years it was impossible to distinguish the real from the fictitious. There is one fact,

however, about which a vast body of evidence leaves no room for doubt: that the young painter spent some time in Verrocchio's studio. It is not at all certain whether he was actually a pupil of Verrocchio; Verrocchio was a great sculptor and an active reformer, but no painter.

The question of the authorship of the paintings produced in Verrocchio's studio, especially those ascribed to the master himself, is still under discussion, although on close examination it is fairly obvious that Verrocchio had little hand in them; there is a total lack of documented paintings by this artist. At any event, this studio, which numbered among its members Botticelli and Perugino, was without doubt the most active centre of artistic life then existing in Florence outside the hallowed walls of the Platonic Academy. Verrocchio was a man of vast culture, with a knowledge of mathematics and music, and possessed some of those intellectual qualities which were later seen to be typical of the 'universal man', Leonardo. Verrocchio's sculpture, which the art historian André Chastel has rightly defined as the 'typical' moment of late fifteenth-century Florentine culture, became the starting-point for Leonardo's stylistic and theoretical experimentation. Verrocchio abandoned the dramatic effects of light which Donatello had used towards the end of his career in favour of a subtle gradation of light and shade and a generally restrained treatment of the faces. And there exist certain works by Verrocchio, such as the *St Thomas* and the *David,* as well as the earlier *Medici Tomb* in the Sacristy of San Lorenzo (1472) where the intellectuality of the conception and the subtlety of the execution suggest the possible direct participation of his young pupil.

Although such suppositions can neither be proved nor disproved (just as there is no concrete proof of the existence of sculpture by Leonardo, in spite of certain documentary evidence), one fact which does appear indisputable is the impetus Verrocchio's studio gave to the ideas and style of the young Leonardo. These ideas, of course, took on quite a new aspect as they were adapted to the measure of Leonardo's genius, but they followed more closely in the path laid down by Verrocchio than did those of other great

pupils such as Botticelli or Perugino. One might in fact say that they became the 'official' voice of Verrocchio's studio in the field of painting.

An illustration of this can be seen in the fact that when the famous *Baptism of Christ*, on which other pupils had already worked, was handed over to Leonardo to be completed, he took it upon himself to change all that was already done, and probably also to remove an entire section of the painting, so as to make it correspond to his own ideas of composition (*pls. 1-3*). The first work which can definitely be assigned to Leonardo is the famous *Landscape Drawing* in the Uffizi, dated 1473. Possibly never in the history of art has the first work of an artist of genius been so individual, so original or so complex as this drawing, which bears within itself the seeds of history (*pl. 4*).

This first landscape coincides, in its rendering of dynamic manifestation of nature, with the theoretical and stylistic concepts later evolved by the mature Leonardo. The vision is captured at a specific dynamic moment and presents a series of organized and corresponding perspective vistas, each with its own precise focal point; in this way it totally departs from the perspective-representational tradition with its single focal point. This complex structure reveals the essence of Leonardo's art, his incomparable balance between artistic will and poetic emotion; the rejection of the rigid geometric form of Albertian perspective coincides with a tremendous emotional power. The encompassing vision can be apprehended through each individual passage of the work. An achievement of this kind naturally presupposes a long period of maturing and experimentation, but we have too little evidence to be able to do more than guess at these preparatory stages.

The most complex problem relating to Leonardo's early years is the extent of his collaboration, while still a member of Verrocchio's studio, in the famous *Baptism of Christ* which is still assigned to Verrocchio in the Uffizi. As already mentioned, Botticelli was working in Verrocchio's studio at the same time as Leonardo; it has been proved (by C. L. Ragghianti) that the entire painting is the work of these two painters. Tradition has always attributed to Leonardo the

first angel on the left and the background landscape behind him. It has been decided that the landscape on the right-hand side is also the work of Leonardo; the visionary intensity with which this section is rendered has been achieved by no other artist. On closer examination we see that the painting of the figure of Christ also bears traces of this new, characteristic and unmistakable style, in spite of a certain graphic tension which might indicate that it was previously sketched in by Botticelli; and the vivid treatment of the water from which the figures rise also reveals the hand of the young Leonardo.

Another problem is the extent of his participation in the *San Bernardo* altarpiece, now in the Uffizi. This was painted by Filippo Lippi, but had been commissioned from Leonardo in 1478. In 1484 it was taken away from Leonardo, whose neglect had obviously tried the patience of his patrons beyond endurance, and given to Filippo Lippi.

It is certain that the whole of the actual painting was done by Lippi, but it is equally clear that in the upper region, where angels gyrate in a welkin of ribbons and floral motifs, we become aware of an infinity of vortices pulsating in space, the unmistakable and inimitable attribute of Leonardo. This is manifested again in a more complex form and with great poetic expression in two small panels which have not always been ascribed to Leonardo by art historians but which, if they were not painted by him in Verrocchio's studio, would necessitate the absurd hypothesis of the existence in late fifteenth-century Florence of an innovating genius who was following precisely the same artistic course as Leonardo. There is no doubt that the *Madonna with the Carnation,* in the Aeltere Pinakothek, Munich, shows the influence of Verrocchio to a great extent; a comparison with a work such as Verrocchio's terracotta *Madonna* in the Victoria and Albert Museum (attributed to Leonardo by certain authorities, including some of the greatest) provides irrefutable proof that this is true. But the element of novelty in this work, even when compared with the greatest of Verrocchio's sculpture or the still more original experiments in the tradition of Verrocchio which followed, such as those of Lorenzo di Credi, is to be found in the infinite

proliferation of perspectival and structural relationships which creates, within the figures of Madonna and Child, climaxes and moments of repose, vortices and dramatic effects of light, which are matched by an involved and intricate treatment of the landscape in depth. Here a trace of Northern fantasy recalls the recent Flemish incursion into Florentine art, with the Van der Goes at Santa Trinità and the Van Eyck at the Palazzo Medici; the world of fable invented by these Flemish artists reappears clothed in Leonardo's unique mysticism (*pl. 5*).

The so-called *Benois Madonna* in the Hermitage, Leningrad, is a similar case; in spite of some iconographic variations, the fundamentals of the composition can already by seen in the preparatory sketch (n. 101 in the Louvre) (*pls. 6 and 7*). This is a stupendous drawing: rapidly defining the upper part of the figures, the artist's brush follows through with the line of the Child's legs and Madonna's hand; *pentimenti* ('second thoughts') become an indispensable means of emphasizing the movement, the play of light on the Child's leg, while the lower part of the body is darkened with a heavy ink shadow which gives balance to the movement of the legs. In transferring the drawing to the canvas, the use of the rapid stroke, applied by an act which evokes the perpendicularity of the artist's approach to the paper, producing an impression of probing into space, is transmuted into a filtering of light as it touches the skin, a variation in the folds of drapery and in the expressions. The way in which the painter expresses the relation between 'gesture' and 'thought' stems from his idea of the fundamental importance of both in the representation of figures. The relationship of movement to emotion (as can be seen, for example, in the current of movement between the gesture of the Child and his expression as he looks at the flower handed to him by his Mother), gives rise to the lyrical continuity of the figure of the Mother, a type which was to remain the model for the first Madonna painted by Raphael as a young artist in Florence.

The most famous and undisputed work of Leonardo's formative years is without doubt the *Annunciation,* now in the Uffizi. This is a classical type of composition, in which

the structure of the perspective, at least in so far as the principal and most prominent element is concerned, acts as a controlling factor and encompasses the whole composition within its close network of axes and co-ordinates – they come together in the little mound alongside the wall on the right-hand side of the painting (*pls. 8-11*). A first move away from the tradition hitherto regarded as historically necessary produces a free and imaginative composition where infinite relationships continuously arise within the painting and between the main subject and the surrounding space. We see too that every episode present on the canvas is organized into elements each of which has an autonomous existence. Within this concept there is justification for the Verrocchian decorativeness, the great emphasis on the portrayal of the clothes and the meadow, the extraordinary collection of botanical 'curiosities', which are all capable of becoming 'individual' and acquiring a descriptive and imaginative autonomy while taking their significance from their position within the framework of the general composition. There is a vast intellectual and poetic distance between the traditional garden background and these little trees, living organisms in the pellucid depths of the picture. The gesture of the Madonna, as she sits framed by the jutting wing of the building, coincides with the reflection made by the falling light upon the stone, while the close-knit perspective network of the bosom, the controlled movement of the interposed suspended gesture, and the withdrawal of the head, become fleeting signals of emotion: the authentic language of genius. This work in itself was able to give a new direction to Florentine art, and not only to the art of painting, after the repetitive dramas of Donatello's last works and the movement towards outmoded forms in the Careggi tradition by artists who strove for continuity.

A link between this work and the later *Adoration of the Magi* is provided by a study for the background of the *Adoration,* in the Uffizi (*pls. 18-19*). This is a vision, carefully organized in perspective, but with the vanishing-point displaced to the left; its basically longitudinal composition is framed by steps and other architectural elements. In the

finished *Adoration of the Magi,* also in the Uffizi (*pls. 13-15*), this vision, in the background on the right, forms the pivot of the whole composition. The traditional sacred scene in Florentine iconography, illustrated in glowing colours by the greatest painters of the fifteenth century, and used by Gozzoli and Botticelli as a means of magnifying and glorifying the House of Medici and its Academy, assumes in the mind of Leonardo an entirely different dimension. Around the group of the Mother and Child, placed right in the centre of the painting, a sea of figures emerges from the hallucinatory visions in the background; the characters move and gyrate like mystical visionaries in a state of prophetic exaltation. At the sides two pensive figures stand motionless, absorbed in their thoughts. The event has acquired a mysterious, almost esoteric dimension; nature enters into the divine act almost on the threshold of creation, and presents a scene of ruin and destruction through which the cries and gestures of man ring out as the awesome tidings are noised abroad (*pls. 13-15*).

Here again, as in the *Landscape* and the *Annunciation,* a central focal point governs the perspective of composition and sends out ripples of inner movement. In this case the discourse has become very much more complex and rigorous; the rejection of colour has become a matter not of choosing to imitate the effect of sculpture or architecture, but of rendering atmosphere and light. The 'unfinished' effect – the *non finito* – whether by accident or design, serves to multiply to the greatest possible extent the reverberations of emotion, the infinite dynamics of the pockets of light, which are here denuded of any episodic character and become identified with the human action (*pls. 16-17*).

A drawing in the Louvre shows the *Adoration* at a stage immediately preceding the final painting. Here the foreground composition – which is even more closely centred around the group of the Madonna and Child – is set far back, so that between it and the spectators there is a wide space, a sort of proscenium or forestage to set off the drama of the visionary experience (*pl. 12*). It is interesting to observe how the brush-stroke becomes identified with the definition of the monochrome, how the tension of the

line corresponds to the dramatic effect of souls divinely metamorphosed into substance through light, in the Uffizi *Adoration.*

Perhaps the greatest example of this type of pictorial process in the work of Leonardo is to be found in the Vatican *St Jerome,* also painted about this time. The figures here are almost emblematic symbols, and the space becomes deepened by gradations of monochrome, from the ochre tones in the foreground, through the livid chalky tones of the figure, to the imperceptibly bluish tones in the left background. And if, as some art historians have pointed out, the dramatic repetition in the figures reveals signs of Leonardo's apprenticeship in the Pollaiolo style, it is Leonardo's solution in terms of light and space that is the hallmark of the new climate of art; a comparison between this work and the *Labours of Hercules,* or the *Dancers,* leaves no margin for doubt (*pls. 20-1*).

The *Portrait of Ginevra de' Benci* is also almost completely painted in monochrome. However, although in this case the painting is 'finished', the flesh tones show a tendency towards a lunar pallor just as they do in the 'unfinished', largely monochrome *Adoration,* and the relation of figure to space is obtained through the medium of the symbolic thicket, now dense and glistening under an evening sky, as the light fades and envelops the world in pallid rays – the hour described by Leonardo as ideal for the painter. This portrait was probably painted in 1478-79 and is perhaps the last work Leonardo produced during his first stay in Florence; in 1478 he left for Milan, disdainfully rejecting the rules of the Neo-Platonic Academy, which considered him, as an 'unlettered man', an object of scorn (*pl. 22*).

In the Lombard court the first work he painted was probably the portrait of Cecilia Gallerani, mistress of Lodovico il Moro; this is the wonderful portrait known as the *Lady with an Ermine,* in Cracow. In it the visionary impetus of the last Florentine works appears to have given place to a calm contemplation of a continuous form, over which an even light produces a sense of weightlessness, while the whole dramatic effect is concentrated in the large, hypersensitive, almost painful hand holding the symbolic animal.

Some years after he had finished this portrait, Leonardo began work on the most famous painting he was to do in Milan, the *Virgin of the Rocks,* now in the Louvre. During those years a group of friends had gathered round Leonardo, friends who were to remain faithful to him for the rest of his life. Having fled from the scepticism of the Florentine court, where men of genius were in abundance and history weighed too heavily, Leonardo was recognized as a master and respected in the more refined court of the Sforzas in Milan. His friendship with Pacioli stimulated his scientific

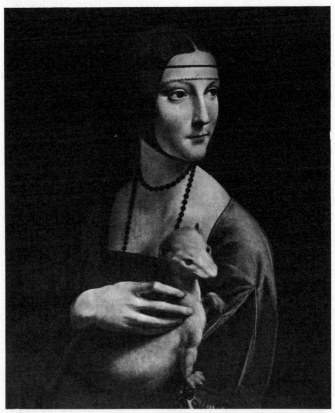

Lady with an ermine (see note on p. 32)

pursuits. His activities in Milan, where he was engaged in putting into practice the Duke's theories and utopian projects, gave Leonardo the opportunity to further his own scientific studies. Meanwhile he gathered around himself a circle of pupils such as he might never have had if he had stayed in Florence; and it is certainly true that the most faithful and devoted of his friends, the most submissive of his disciples, were all Milanese; all mediocre artists, in the main incapable of fully comprehending the measure of Leonardo's genius, but devoted to him personally, so that they were able to fill the emotional gap in his life which his great intellect and the curse of his nature had inflicted upon him. About the year 1483, Leonardo received from the Confraternity of the Conception a commission to paint a triptych representing the Madonna, Jesus and two angels; this became the *Virgin of the Rocks* (*pls. 23-9*). It seems that the Duke himself took possession of the painting and obliged Leonardo to make a replica of it. This he did in 1495, together with De Predis (who had been responsible also for the angels in the first version). The original version is now in the Louvre (although the angel musicians are in London), and the copy is in the National Gallery (*pl. 30*). There is no doubt that in this painting Leonardo's treatment of light has attained its most complex form. Two sources of light – one more definite, in the background, the other more indeterminate, in the foreground – govern the composition, bathing the shapes in a somewhat watery reflection which multiplies the dynamics of vision to infinity. The texture varies between the rapid brush-stroke and a graphic definition of the complex foliage, and attains a highly intense atmospheric effect as the two sources of light pick out some of the details emerging from the suffused glow. His vivid imagination transfigured the elements found in the Northern European painting then the fashion in Florence, in works of such poetic grandeur that they have influenced the development of artistic form down to our own time. Everywhere in the second version of this altarpiece the hand of De Predis is to be seen, in the less dramatic treatment of light and in the use of pastel colouring effects, which Leonardo avoided in favour of monochrome.

15

The *Portrait of a Musician,* now in the Ambrosiana, is datable on stylistic grounds to this period. The heavy treatment of some parts of this painting indicates that here too De Predis had some part in the work (*pl. 32*), and another painting once attributed to Leonardo, the *Portrait of a Lady,* also in the Ambrosiana (*pl. 33*), is now definitely ascribed to De Predis. About the year 1495 Leonardo began work on the *Last Supper* in the refectory of the Monastery of Santa Maria delle Grazie in Milan. He experimented with a technique based on an impasto using oil and tempera, to be placed on a wall covered with a layer of varnish made of a gesso mixture. But the technique proved unsatisfactory and the painting rapidly deteriorated, to such an extent that by the middle of the sixteenth century it was described as being in a completely ruined condition, and after numerous restorations which have continued up to the present day, the fresco we now see is only a shadow of the original painted by Leonardo.

Below the Bramantesque vaulting of the room the scene is enacted against a background of classical perspective with a central focal point. There is an illusory effect of prolongation, as the room opens out on to the countryside through the arches in the background. The broad scale of the figures is thus placed within a structure adapted to ' human ' measure according to the Renaissance norm; this gives rise to the effect of monumentality which was to characterize the painting of the sixteenth century. All the main figures are carefully arranged so as to balance each other as well as the figures in the other groups. This calculated balance is enhanced by the diffused light playing over the whole work, so that the figure of Christ, which is partly against the light, stands out in isolation against the luminous chalky background. Each of the figures is placed in such a way that it occupies a definite portion of space, which barely varies from figure to figure (except in the central portion, where the figure of Christ is set apart), and the effect of this is to concentrate the greatest intensity on the central point, where the dramatic moment is focussed and held for ever. The tradition of isolating the figure of Judas on the outer edge of a painting, which Leonardo followed in his

preparatory sketches for this work, was abandoned in the final version in order to avoid fragmentation and a consequent decline in dramatic effect (*pls. 34-47*).

Leonardo returned to Florence in 1500 and stayed with the monks of the Santissima Annunziata, who commissioned the *St Anne* cartoon, now in the Louvre. In a letter written by Fra Piero da Nuvolara, and in Vasari's writings, mention is made of a cartoon Leonardo completed, also for the monks of this monastery. When this was exhibited, it was greatly admired by all the citizens. This might be identified with the National Gallery cartoon of *The Virgin and Child with St Anne,* were it not for discrepancies between this version and the cartoon as described by the monks. The unusual spatial relationship between the figures themselves and between figures and background was a great structural innovation, later adopted by Raphael, Fra Bartolommeo, Andrea del Sarto and the Mannerists, and in fact imitated by painters throughout the sixteenth century. The significance of this work will be better understood when we consider that it was produced at a time which represented perhaps the most crucial moment in fifteenth- and sixteenth-century painting, when the influence of the teaching of the great Florentine masters of the previous generation still lingered, while young artists of the same generation as Leonardo (among them Botticelli, for example) were carried away by the fantastic imaginings of Flemish artists which reached them by way of Piero di Cosimo (*pls. 48-51*). The *St Anne* cartoon initiates a new period in the history of Renaissance art, just as the *Holy Families* of Raphel and Michelangelo's *Doni Tondo* did in their turn. This is the period which has far too often been defined by the pseudo-historical term 'classicism'. It is in fact, quite the reverse: a highly revolutionary way of stating the relationship between man and object, with far greater flexibility and unlimited variety, going far beyond figurative representation, and bearing the mark of one of the crucial moments in the history of art. It was during this stay in Florence that Leonardo tackled the complex problem of the fresco representing the *Battle of Anghiari* in the Palazzo Vecchio; this work was never completed, and even the cartoon, so famous that it was

considered a 'school of draughtsmanship' for every painter, was soon destroyed. Apart from some contemporary and later copies (that by Rubens is very well known) all that is left of this work is a series of preparatory sketches; these form one of the most truly organic units in the whole of Leonardo's graphic work. The overall composition, which was to develop through a vast space, centred on a group of horses and riders; this was to be the focal point of the composition, where the ideal of movement and light, the feeling of luministic dynamism, became manifest (*pls. 68-71*). In this work Leonardo went beyond the point reached in his theoretical studies of light and movement to include also his special interest in the dynamics of physiognomy (a comparison between the grimaces of the horses and the fierce expressions of the men is revealing), and knowledge obtained through scientific research was applied to heighten the lively dramatic effect of the composition.

The third work of this Florentine period was the portrait of a woman supposed to be Monna Lisa, wife of Francesco Bartolommeo del Giocondo. The *Mona Lisa,* most famous of Leonardo's portraits, brought a revolutionary element into the development of the Renaissance concept of·portraiture. With certain exceptions, portraits by late fifteenth-century artists had tended to become schematic, but now the relationship between figure and background was no longer dependent upon the usual recession of planes in even gradation. The effect partly foreshadowed in the *Portrait of Ginevra de' Benci* is completely achieved here, and the *Mona Lisa* is an instant of total illumination, carried with equal intensity through to the rocks and sky in the background. The famous 'enigmatic' smile thus becomes a subtle vehicle for the refraction of light; it is as if we were present at the very birth of light, as though the splendour of this moment could never be repeated, and light never again have the same intensity (*pls. 52-5*).

Another work begun, or at least conceived, in Florence was without doubt the lost *Leda*; this is known from the evidence of a drawing executed by Raphael in Florence during these years. The importance of the *Leda* in the history of European art will be realized when we consider that

this figure, the countless viewpoints of its complex internal dynamics, the serpentine movement of the body, became one of the basic models for all classical sixteenth-century figures. Such a model may be traced from the 'serpentinatura' of the figures of Michelangelo (although the treatment of space and the dramatic effect are here quite different) to certain forms of composition employed by the 'classical' Raphael, and the involved structures of the so-called 'mannerists' (for example, Pontormo's harsh and disturbing interpretation in the painting now in the Uffizi).

Leonardo returned to Milan, then left for Rome and from there fled to France; in his anxious and choleric old age he produced only one painting, the *St John,* now in the Louvre. This painting expresses the extreme consequences of Leonardo's treatment of light; the light is continuously filtered from the dark background to the more prominent planes in the foreground, and itself becomes an expression of space and physiognomy, merging with the figure and the face, as it leans forward and smiles enigmatically, and with the symbolic raising of the finger; this is no longer 'a voice crying in the wilderness' but the guardian and witness of an initiatory secret, a means to the comprehension of the essence of humanity and hence the cosmic essence (*pl. 56*). Respected, and indeed revered, by the court, comforted by the company of Melzi and Salai, the half-paralysed old man felt that his life was drawing to a close. It was then that he produced what were perhaps his greatest studies of the natural forces which create and destroy the cosmos. In these studies Leonardo depicted cataclysms, convulsed currents, skies in torment, and the forces of wind and wave. The scientific approach to the drawing in these works is at the same time an expression of the greatest human suffering. Now Leonardo was alone before the powers of the cosmos; and this is how he wished to die, in his own words: 'Be thou alone and thou shalt be all thine own'.

Because of the total lack of any completed sculptures, we have little exact knowledge of Leonardo's activity in this field; we know from documentary evidence and his own writings that he considered himself equally gifted in both arts – in fact, he considered that he was particularly skilled

in the difficult task of bronze casting. His youthful activity in the studio of Verrocchio, himself a sculptor and only to a far lesser degree a painter, makes it highly likely that he began as an apprentice sculptor, although it is a fact that all the works of sculpture which have been attributed to Leonardo's early years, from the terracotta *Madonna and Child* in the Victoria and Albert Museum to the *Portrait of a Lady with Flowers* in the Bargello, are to be assigned either to Verrocchio himself or to Antonio Rossellino. There is no documentary evidence of any sculpture in existence which can unhesitatingly be ascribed to Leonardo. This assertion is not invalidated by the existence of bronzes and waxes which have been assigned to Leonardo with little justification, some of them intended for the decoration of the Francesco Sforza monument, others for the Trivulzio monument. These two monuments were the great projects which occupied Leonardo's mind for many years, but were never completed. Reference has been made to the fact that Ludovico il Moro commissioned a monument in memory of Francesco Sforza and that Leonardo completed only the clay model of the horse, which was later destroyed; a clear impression of the basic idea for this monument can be gained from the series of silverpoint drawings at Windsor Castle, where we see especially how Leonardo's treatment of the figure of the horse developed from one drawing to the next. In one of the first sketches he envisaged the horse as a moving figure executing a leap into space, a view which recalls Leonardo's studies in the Pollaiolo style. Later, the horse was shown with all four legs on the ground, in the classical tradition, and further developments were introduced before the final version was produced in 1493.

About twenty years later, Leonardo was engaged on a project for a funerary monument to Giangiacomo Trivulzio, a general in the service of the King of France. This monument, in the church of San Celso, Milan, was to consist of a sarcophagus acting as a base for an equestrian statue of natural size. From studies for this work which have come down to us we see how the idea for the composition arose directly out of the final plan for the Sforza monument. The restrained dynamism gave new significance to the traditional

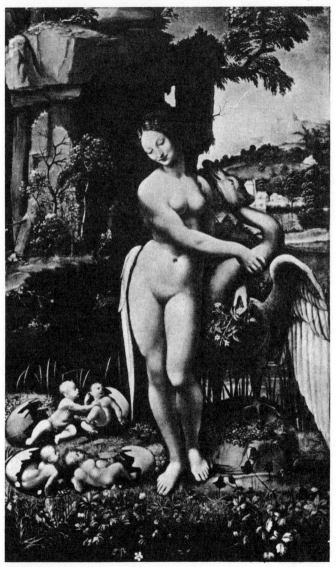

Leda (see note on p. 36)

equestrian iconography as seen in the statue of Marcus Aurelius or the works of Verrocchio and Donatello. To the plan for this monument, as well as to the preliminary studies for the *Battle of Anghiari,* are related the series of small bronze and wax figures representing battle scenes and horses executed by Gian Francesco Rustici, a pupil of Leonardo's in Florence. Rustici was also responsible for the execution of the only sculptural project by Leonardo to have come down to us in completed form: this is *St John the Baptist between a Pharisee and a Levite* over the north door of the Florentine Baptistery. According to Vasari and a note written by Leonardo himself, this sculpture was executed under the constant guidance of Leonardo during his second stay in Florence.

There are no finished works to bear witness to Leonardo's studies in the sphere of architecture; we know he spent a long time planning the dome of Milan Cathedral, and there are innumerable plans of fortifications which he produced for the Dukes of Milan and Valentino. But the most interesting architectural work left by Leonardo is his draft *Trattato sull'architettura,* of which much evidence still remains. We know that this treatise was planned in two sections, the first being an exposition of the doctrine of Orders and architectonic forms, the second a discourse on building techniques. From fragments and numerous drawings which remain (prototypes of the analytical architectural drawing) it is apparent that the tremendous importance of Leonardo's theories lies in the fact that they provide a link between the theories of the fifteenth century – not only those of Brunelleschi and Alberti, but including also Filarete and Francesco di Giorgio – and the 'classical' architectonic theories of the mature Bramante. They later became the model for Serlio's treatise on the Orders of architecture. We must see in this continuous preoccupation with theoretical investigation, resulting in the creation of an architectonic ideal which was more valid as an abstract theory than as a practical realization, the cause of Leonardo's failure to carry his countless ideas through to completion.

There is no doubt that his most important theoretical work is the *Trattato della pittura,* although unfortunately this too

has reached us in fragmentary form. This treatise is undoubtedly the greatest contribution to the theory of painting produced at any time during the Renaissance. We find in it an examination of all the themes which were under discussion at the time. Foremost among these is the dispute concerning the primacy of the arts, which Leonardo naturally settles in favour of painting, which he classifies as a ' natural science' because of the scientific and mathematical basis of this art. He pursued the theories promulgated by the first Florentine writers on the theory of art, but followed an original line of development through the concept of ' knowledge conquered by experience' as opposed to what he regarded as the ' fallacious spiritual sciences' of the Platonic and Aristotelian traditions. And it is in this sense that the highest value is placed upon painting and it becomes a science, even a philosophical system. The generally accepted idea of the primacy of painting among the arts gave rise to a whole cultural tradition which lasted throughout the sixteenth century, even in places where Leonardo's thought could not have penetrated; but Leonardo's view of the supremacy of painting as a combined art and science, capable of representing a synthesis of all forms of expression, is absolutely original. It is apparent that for Leonardo the concept of ' imitation' was the ultimate essence of artistic expression, implying a spiritual elaboration of the natural model; a true ' second nature'.

Leonardo considered the essence of painting to lie in relief, in rigorous modelling by means of light and shade, enhanced by tones of ' semi-obscurity'; a second basic factor in painting being psychological expression, manifested mainly through ' motion', the features, and gestures.

Another important part of the *Trattato* deals with the theory of proportions, encompassing the law of perspective; this was the formulation of what might be called a ' discovery' of Leonardo's; for although the theory was derived from the system of perspective traditional to Florentine art, it is considered by him from the point of view of changes in the actual proportions as they are affected by movement. The last part of the *Trattato* is devoted to an analysis of the structure of the muscles.

Leonardo is probably the supreme example of the Renaissance scholar, for whom art and science are inseparable elements in the acquisition of knowledge. In fact, in Leonardo's view art becomes itself a form of cognition, so that there exists a close analogy of method between artistic representation and scientific description. Both art and science have their roots in experimentation, a term already understood in a quite modern sense – the accumulation and exposition of the greatest possible number of relevant facts and observations – and through a direct recourse to nature the barrier interposed by traditional scientific literature between art and science was finally broken down.

In this connection, although we should not overemphasize Leonardo's status as an ' unlettered man ', there is no doubt that his lively interest in events as they occurred, without thought of academic or cultural considerations, enabled him to adopt a free attitude of investigation into every aspect of nature, none of which he judged unworthy of observation and explanation.

' On seeing that I could not derive material of great use or pleasure, because men born before me have taken for themselves all that is useful and necessary, I will do as the man who through poverty is the last to arrive at the fair; being unable to obtain anything else, he will take things already seen by others and rejected by them because of their low value. To this despised merchandise, left behind by many buyers, I will add my feeble load, and with it will go, not through the big cities, but through poor towns, selling it for whatever price it is worth. ' In these ironical words Leonardo reveals his awareness of a method he felt necessary to renew the relationship between man and nature. A second important element common to both art and science, besides their experimental character, is the use of mathematics to establish criteria and general laws by which natural phenomena can be categorized and described. Leonardo was the first natural scientist to make conscious use of mathematics as an aid to understanding and representation, and it is significant that one of the few identifiable sources of his works is Archimedes. The basis of Leonardo's approach to science lies in the rejection of both theology and the

occult as sources of knowledge; the only possible and valid method, in his view, is experimentation based on mathematics. Mathematics becomes a means of establishing a harmonic relationship between the human microcosm and the macrocosm.

The vital link between the creative and the scientific aspects of Leonardo's work lies in his drawings, where artistic expression and accurate scientific description exist side by side. For Leonardo drawing was a tool of research into medicine, physics and natural science, as well as engineering and – with amazing results – anatomy. In the field of physics, we know that Leonardo studied hydraulics and mechanics, paying particular attention to the importance of the power-to-weight ratio in aerodynamics. These studies are reflected in some of his most visionary drawings. In this connection, he turned again to the theory of *impetus* propounded by the Scholastic philosophers; however, he made so many fundamental innovations that he can be said to have created the modern science of mechanics, clearly foreshadowing Newton's laws of motion. Leonardo also undertook research into chemistry and designed distillation apparatus, cooled by running water, and chimney-shaped furnaces that could be stoked continuously. He attacked alchemy for its attempt to make ' simple substances ' (chemical elements), but approved of its manufacture of ' infinite compounds ' for medical and technical purposes. From alchemy too he retained the conviction that minerals are generated in the bowels of the earth. He also studied and depicted the physical structure of the earth and investigated the nature of fossils. It is difficult to obtain a precise idea of Leonardo's cosmological theories, but there does exist a statement that the sun is immobile.

This vast *corpus* of notes, plans, studies, assumptions, discussions and redefinitions remains without doubt one of the supreme achievements of the human mind. A sentence of Schlosser's relating to Leonardo's theoretical writings might be applied to all his activity: ' The fragments left by Leonardo are the most splendid monument bequeathed to us by the artistic literature of Italy;... his towering figure is a summation of the fifteenth century and a herald of the modern age '.

Leonardo and the critics

The vast amount that has been written on the subject of Leonardo, as an artist, a scientist, a philosopher and a man, constitutes the most complex, contradictory, and in a sense absurd, of all instances of myth-creation. The process began with Vasari's short and somewhat equivocal biography, and was continued by countless others, from Burckhardt's codification of the Universal Man to Benedetto Croce's reappraisal of Leonardo's intellectual activity; it has produced specialized studies on the 'theory' of Leonardo (the greatest of these is Schlosser's) and his paintings and drawings (on which all the greatest art historians have written). The great Leonardo debate continues, and agreement remains as far away as ever.

The problem most easily solved is that of Leonardo the artist. Apart from the uncertainty which still exists regarding his early years, and the doubtful attribution of certain works, the catalogue of the few oils and countless drawings left by Leonardo does not present any special points of doubt (with the exception of the *Codices,* where revision is still badly needed). Leonardo emerges as one of the greatest artists the world has ever known. There has never been any confusion as to his position among painters, nor could there ever be. He was already referred to by Vasari and his contemporaries as one of the 'summits' of art, together with Michelangelo and Raphael, and has continued to hold this place in the estimation of later generations without suffering the misunderstanding and belittlement to which even Raphael and Michelangelo have occasionally been subject.

Of far greater complexity is the problem of Leonardo the man and the thinker. Both adulation and denigration have often been wildly, even absurdly exaggerated. Leonardo has been made into a prototype, the Renaissance man *par excellence,* and at the same time he has been considered an innovator, completely freed from the bonds of contemporary history and projected absurdly into some prophetic future.

Vasari was the originator of an error which for many years prevented an exact understanding of Leonardo's mind and humanity. By a conscious use of innuendo and distortion, Vasari presents Leonardo as a bitter foe of that official culture which was sanctified by Careggi. Vasari himself was instrumental in reviving its ideas on the respective values of the figurative arts under the aegis of the mid-sixteenth-century imperialism of Grand Duke Cosimo.

As Garin has rightly pointed out, there are certain elements in the Leonardo myth that border on the magical. He appears as a very handsome man, so strong that he could easily bend an iron bar, a man of fantastic imagination and vision, with a love of the grotesque which Vasari believed was inspired by Piero di Cosimo, although in Leonardo it takes the form of an evocative and superhuman awareness of the realms of magic. From this point of view Vasari's description of the *Mona Lisa* becomes clear: in this painting, he asserts, nature is evoked in its most exact and minimal details according to a procedure typical of magic, by which the perfect effigy conjures up the living soul. For this reason Leonardo the 'miraculous and divine', famous musician, prodigious mathematician, investigator of the properties of grasses, the movements of the spheres, the sun and the moon, is in the first edition of Vasari's *Lives* openly accused of heresy. 'And so numerous were his caprices... whereby he formed in his mind so heretical a concept that he did not attach himself to any religion, perhaps esteeming it better to be a philosopher than a Christian.' Not even the death-bed conversion is lacking; we are told that, when Leonardo felt that his life was drawing to a close, 'he returned to the faith of his fathers with many tears', confessed and took communion.

The myth of Leonardo grew through the centuries, until by the late romantic period it had grown to alarming proportions; the extra-human qualities had now become a superhuman halo, and the 'Universal Man' of Burckhardt, the direct and greatest heir of Leon Battista Alberti, was superseded by a mythical figure, ranging over all art and science with wings both human and divine, the anticipator of every science, a fascinating symbol, exploited in literature

27

in the Merezhkovsky cycle, to take the most typical example. This abnormal and grossly exaggerated portrayal of the man and thinker was attacked by Benedetto Croce in a famous lecture which he gave in 1906. His aim was not to debunk the Leonardo myth, but rather to restore his reputation to its true dimensions; this could be discovered only by systematic research and explanation. And although the lack of system in Leonardo's theories has led to an excessive denigration of his scientific activity – a typical example of which is to be found in the writings of Olschki – scholars such as Gentile, Cassirer, Luporini, Garin, and Chastel have nonetheless devoted themselves to studying and expounding his thought. And if there are still many points of argument regarding the value of his speculative thought (and only a careful re-reading and dating of the manuscripts can clarify the issue), the outline of the towering figure of Leonardo is clear and sharp; his greatness lies not only in his soaring imagination but also in those elements he had in common with the rest of mankind. He emerges as a lonely genius, now bewailing his lot, now exalted by the thrill of creation; an artist who added a whole new dimension to the rational, creative and emotional life of humanity.

Notes on the Plates

1-3 Baptism of Christ. Oil on panel, 150 × 178 cm. Florence, Uffizi. Painted in Verrocchio's studio for the Church of the Monastery of San Salvi. The problem of Leonardo's share in this work is complex, although art historians have often simplified it by assigning to Leonardo only the angel in the left foreground and at the most a part of the landscape above the figures of the two angels. This is a vast question encompassing an entire re-examination of the paintings produced in Verrocchio's studio. There is no documentary evidence on the subject, but Vasari denies that Verrocchio himself took any part in the work. As regards the *Baptism* in question, the most detailed opinion is that of Ragghianti (1954); he sees the work of various artists (at least three) in this painting, ascribing the execution of St John, the first version of Christ, the second angel on the left and the landscape on the right to Botticelli. He ascribes to Leonardo, besides the re-proportioning of the panel as a whole (introducing asymmetry in relation to the axis formed by the outstretched hands of God), the execution of the first figure of the angel, the final version of Christ, the two backgrounds on the left and right, and the final version of the plane upon which the figures rest. This opinion provides an exact confirmation of the hypothesis formulated also by Chastel, to the effect that Leonardo was a pre-eminent figure in Verrocchio's studio and that the 'inventions' and special stylistic details which were typical of its output were not, as many writers have felt compelled to suppose, the work of Verrocchio but of Leonardo.

4 Landscape. Pen on paper, 19.5 × 28.5 cm. Florence, Uffizi, Gabinetto dei disegni e stampe, No. 8, p. *recto*. Inscribed in the upper left section 'dì di Santa Maria della Neve addì 5 daghosto 1473' (the day of the Holy Virgin of the Snows, 5 August 1473). This is the only dated work and probably the earliest of Leonardo's extant works. According to Seidliz, the place depicted may be identified as near the Castle of Poppiano between Vinci and Pistoia. Another possibility is that this is part of the road from Montelupo to Signa.

5 Madonna with the Carnation. Oil on panel, 62 × 47 cm. Munich, Aeltere Pinakothek, No. 7779. It was bought in 1889 from a Bavarian collection. Berenson, Clark and Heydenreich considered it to be only in part the work of Leonardo. According to Fabriczy and Hildebrandt, it is by Leonardo and Lorenzo di Credi; while Bode, Suida, Venturi, Valentiner, Ragghianti and Goldscheider say that it is by Leonardo. It was painted during his apprenticeship to Verrocchio.

6 Madonna with Child. Pen and ink on paper, 33 × 25 cm. Paris, Louvre, Cabinet des Dessins, No. 101. This is obviously a first version with variants of the *Benois Madonna*, drawn immediately before 1477.

7 Benois Madonna. Oil on panel transferred to canvas, 86 × 98 cm. Leningrad, Hermitage Museum, No. 1618. It belonged to the Benois collection, from which it passed to the Hermitage in 1914. It was bought by a member of the Benois family from an Italian merchant in Astrakhan in 1824. The landscape comprised within the window has been erased. This is usually identified with one of the 'two Marys' about which Leonardo wrote in 1478 and catalogued as 'almost finished' in the inventory he made, also in 1478, just before he left for Milan. In spite of the reservations of certain historians, this has now passed into the catalogue of paintings definitely attributed to Leonardo. Bodmer has suggested that Sogliani shared in this painting. Heydenreich considers it 'unfinished' and bases this opinion on Leonardo's inclusion of it in his own catalogue of unfinished works. There are two sources of evidence in support of its authenticity: the first is the drawing No. 101 in the Cabinet des Dessins in the Louvre representing a Madonna and Child, and obviously a sketch for this work; the second is to be found in the large number of copies of it which remain, and can be attributed to the great names of Florentine painting throughout a whole century.

8-11 Annunciation. Oil on panel, 98 × 217 cm. Florence, Uffizi, No. 1618. This was painted for the Monastery of Monte Oliveto and brought to the Uffizi in 1867. Although all art historians now agree that it is Leonardo's work, at one time opinions differed greatly. Apart from the assigning of this painting to the list of Verrocchio's presumed works by Maud Crutwell and others, it has also been assigned by Morelli to Ghirlandaio, and by Berenson to Leonardo and Lorenzo di Credi working in collaboration. Liphart was the first to assert that the entire work was by Leonardo. It was painted about the year 1474, a date which excludes the collaboration of Lorenzo di Credi, who was a pupil of Verrocchio's from 1480 to 1488, when Leonardo was already in France. Moreover, the presence of collaborators (and even Heydenreich ascribes the execution of the entire figure of the Madonna to someone other than Leonardo) would seem to be incapable of proof.

12 Adoration of the Magi. Ink on paper, and sanguine. 29 × 16.5 cm. Paris, Louvre, Cabinet des Dessins, R.F. 1978. This is probably a first sketch for the Uffizi *Adoration*; this is confirmed by the fact that the iconography is identical. Therefore, this work is datable to immediately after 1481, the year Leonardo received the commission for the altarpiece.

13-17 Adoration of the Magi. Oil on panel, 258 × 243 cm. Florence, Uffizi, No. 1594. This work was commissioned by the monks of San Donato a Scopeto in 1481, and when Leonardo left for France the next year, it remained unfinished in the house of Amerigo de' Benci. Some critics, including Meller and Strzygowski, believe that Leonardo did some more to this painting during his second stay in Florence in 1503, but this is unlikely. The problem presented by the state of 'non finito' in this work can be readily understood

within the ambit of the evolution of his style and thought – as it can in the case of Michelangelo, although that is where the resemblance ends. The adoption of monochrome indicates a rejection of the traditional conventions – a rejection, in fact, of the very limitation which, through the writings of Vasari as well as through an erroneous interpretation of Leonardo's own writings, has been considered a prime element in his style. It is most unlikely that this is the result of leaving the work half-finished, when we consider the great expressive power of the painting as it appears to us today, for that would imply that the artist considered it a matter of indifference. Apart from external events, his more or less unforeseen and sudden departure for Milan, and the slowness of execution Leonardo found necessary in order to produce his particular effects, the Uffizi *Adoration* could hardly be more finished even by the highest standards of refinement and descriptiveness current in Verrocchio's studio.

18-19 Study of landscape, architectural motifs and figures. Pen on paper. Florence, Uffizi, Gabinetto di disegni e stampe, No. I 436. This is a study for the background to the *Adoration of the Magi* now in the Uffizi (*pls 13-17*).

20-21 St Jerome. Oil on panel, 130 × 75 cm. Rome, Vatican, No. 337. This was bought in 1820 by Cardinal Fesch, Napoleon's uncle, in a sale held in Rome; it had been used as the door of a small wardrobe. The upper part of the panel, showing the head of the saint, was missing; five years later it was found by the same Cardinal in a shoemaker's shop. In 1845 the painting entered the Vatican gallery and was restored. Its authenticity is certain. The date of execution can also be easily ascertained because it is extremely close stylistically (including the adoption of partial monochrome) to the Uffizi *Annunciation* painted soon after his departure for Milan, in the years 1481-82.

22 Portrait of Ginevra de' Benci. Oil on panel, 42 × 37 cm. Washington, National Gallery. The whole lower edge of the painting has been damaged, where the folded hands we find again in the *Mona Lisa* appeared. This damage probably affected about twenty centimetres (8 inches) of its height. Vasari informs us that Leonardo executed a portrait of 'Ginevra d'Agnolo Benci' on his return to Florence in 1500. We find the same information without the date in the Anonimo Magliabechiano and the Anonimo Gaddiano. From this there arise two problems: whether this portrait is to be identified with the work in question and the exact year of its execution. The first can readily be solved through the symbolism which also enables us to identify the later *Portrait of Cecilia Gallerani*. The pointed branches, interwoven against the background, have a clearly symbolic significance, and are in fact juniper branches, a reference to the model's name. The second problem, in spite of Vasari's hypothesis, also leaves slight room for doubt; in addition to the fact that the painter assiduously frequented the Benci house

before leaving for Milan (and Vasari himself bears this out when he states that it was in one of the Benci houses that Leonardo left his unfinished *Adoration*), the modelling of the figure, the extremely vibrant but still minutely portrayed relationship between the light and the objects, the use of the brush stroke to emphasize these relationships in a particularly sharp 'and elegant movement, all these factors situate the portrait within the years immediately prior to 1480 without any possibility of doubt.

Lady with an Ermine (illustrated in black and white). Oil on panel 55 × 40.4 cm. Cracow, Czartoryski Museum, No. 180. In the upper left section there is an apocryphal inscription: ' La belle Ferroniere Leonard d'Awinci '; the spelling betrays its Polish origin. The painting was acquired in France during the time of the Revolution. A recent examination by ultra-violet rays (1955) has revealed in the left background certain architectural features and a window (very similar to that in the *Benois Madonna*) which Leonardo himself obviously overpainted in the final version. It has been attributed to De Predis by Seidlitz, to Boltraffio by Gronau and Siren; to Leonardo by, among others, Berenson, Clark, Heydenreich, Ragghianti and Goldscheider. It is thought to be a portrait of Cecilia Gallerani, the mistress of Lodovico il Moro; this is likely because the Ermine is the emblem of the Sforza family. The work can be ascribed to the first years of his stay in Milan.

23-29 Madonna with the infant St John and an angel (known as the *Virgin of the Rocks*). Oil on panel transferred to canvas, 197 × 120 cm. Paris, Louvre, No. 1599. The work has suffered considerably through being transferred to canvas at the beginning of the nineteenth century. The work was commissioned by the Confraternità dell'Immacolata in Milan on 25 April 1483, from Leonardo and his assistants Evangelista and Ambrogio De Predis. It was completed in 1485, and consisted of the central panel which was completely executed by Leonardo, and two angels on the sides executed by De Predis (Nos 1611 and 1662 in the National Gallery, London). Some historians believe, however, that these two angels formed part of the copy, mainly the work of De Predis, which is now also in London. The work was bought from the fraternity by Lodovico il Moro and probably reached France a few years later, if we can accept Venturi's opinion that it was in the possession of Francis I when Leonardo was in France. The first document referring to its presence in France is dated 1625, when it was listed at Fontainebleau.

30 Madonna with the infant St John and an angel (known as the *Virgin of the Rocks*). Oil on panel, 189 × 120 cm. London, National Gallery, No. 1093. Leonardo and De Predis were commissioned by the Confraternità della Concezione to produce this as a replica of the picture now in the Louvre. The work took a long time; in 1505 De Predis received a supplementary payment from the fraternity and when Leonardo returned to Milan from Florence in 1507 he also

received a supplement of one hundred lire; when he returned to Milan from Florence the following year he received a further supplement of a hundred lire. The panel remained *in situ*, in the Chapel of the Confraternità della Concezione in the church of San Francesco, until 1718 when it was sold. It passed into the collection of the Earl of Suffolk in 1785, and in 1880 became the property of the National Gallery. The controversy concerning this work refers especially to the extent of the participation of De Predis. Bode ascribes to Leonardo the whole execution of the painting, but this is extremely unlikely, not only because of the marked difference in colour and light effects from the work in the Louvre, but above all the marked accentuation throughout the whole work of that Leonardesque mannerism which is so typical of De Predis. On the other hand, Leonardo's frequent absences from Milan and the supplementary payment made to his assistant during his absence are arguments in favour of this hypothesis.

31 Portrait of a Lady called La Belle Ferronnière. Oil on panel, Paris, Louvre. The 'Ferronnière' is a typical Lombard female adornment consisting of a band worn over the forehead, often with pearls or precious stones. A recent examination under ultra-violet light showed that the portrait was first sketched in without the balustrade which can now be seen along the lower edge. The attribution of this work is much contested by art historians; Leonardo's authorship is denied by Frizzoni, Bodmer, Goldscheider, and Suida (who considers it to be by Boltraffio), while it is supported by Venturi, Berenson, Beltrami, Holmes and Heidenreich. There can be no doubt that pupils shared in the work, especially the painting of the draperies. But a comparison with other ascertained works of Boltraffio, or indeed of any other Milanese follower of Leonardo's, shows no identifiable stylistic affinities with this painting; we have here the indubitable imprint of Leonardo, not only in its great poetic expression, but also in the quality of the paint, the feeling of volume and the intense relationship between the figure and the darkened background. This was something Leonardo's followers never understood; the experience of Florentine art together with the imagination of Leonardo himself are reflected in this superb portrait. Even the best among the pupils distorted this Florentine painting so that in their hands it became a thing of flaccid smiles, plush and tedious backgrounds, in which the meaning of space and light became lost. The person portrayed may be Lucrezia Crivelli, the mistress of Lodovico, whose portrait, according to Pietro da Novellara, Leonardo painted in 1501.

32 Portrait of a Musician. Oil on panel, 43 × 31 cm. Unfinished; restored in 1905. Milan, Ambrosiana. The attribution of this work to Leonardo remains problematical. In spite of a certain hesitancy due to the unfinished state of the painting – probably the only time this occurred unintentionally in Leonardo's work – and the consequent schematic effect of the outlines and the lighting, this portrait

seems to me to betray the continual presence of the hand of Leonardo. The composition is of exceptional structural force, and is emphasized by the hand that holds the sheet of paper and contrasts with the extremely rigid lines of the figure. This hand, square and sensual, is similar in its effect to the hand in the *Lady with an Ermine*. The work was probably executed around the year 1500, before Leonardo returned to Florence.

The subject of the portrait, as suggested by Beltrami, is now almost universally believed to be Franchino Gaffurio, a friend of Leonardo and the director of the cathedral choir; he was the author of *Angelicum ac divinum opus* and *Practica Musica*, for which Leonardo produced illustrations in 1496. In the sheet of music which the musician is holding the inscription CANT. ANG. can be deciphered. This has led some people to believe that the subject of the portrait may be Angelo Testagrossa, Isabella d'Este's singing teacher (*maestro di canto*).

33 Portrait of a Lady. Oil on panel, 51 × 34 cm. Milan, Ambrosiana. The question of the authorship of this portrait is fairly complex, because of the discrepancy in style and quality it presents, although there is no doubt that it follows the pattern of Leonardo's works. It is in the tradition of fifteenth century Lombard portraiture, although the influences of Florence and Venice are also apparent. In any event, the sharp profile, the decided linearity of the structure, are in clear contrast with both the style and expression of Leonardo. We can compare it with the two profile portraits which are definitely attributable to him: the drawing of Isabella d'Este now in the Louvre, and the silverpoint drawing of a girl, at Windsor. In these, the sharp profiling of the face acquires an unexpected spatial and dramatic force by the three-quarters turn of the shoulders, producing a vivid movement of light and focus. If this creative originality is missing in the pose of the Ambrosiana portrait, it is nevertheless present in many passages of the painting, especially the face; in my opinion, Leonardo was responsible for the painting of the table, and perhaps sketched in much of the upper part of the painting, leaving the execution to a pupil, perhaps De Predis, who greatly changed the lower portion in accordance with his own Lombard taste. Several opinions have been put forward as to the identity of the lady portrayed; one of the most likely is that she was Bianca, the wife of Lodovico il Moro. This is the opinion of Müller Walde, based on the evidence of a commission Leonardo received in 1491; Bode, Gronau and Beltrami consider that the entire work is by Leonardo; while Morelli, Berenson, Boamer and Sirèn believe it to be by De Predis.

34-47 The Last Supper. Fresco, 420 × 910 cm. Milan, Refectory of Santa Maria delle Grazie. The state of preservation of the fresco is very poor. In order to obtain a clouded effect and thick colour, Leonardo rejected the traditional fresco technique, requiring great rapidity of execution, and experimented with a technique of his own invention, whereby a special varnish was spread over plaster

and the colours painted over it. This technique was soon found to be faulty and by the middle of the sixteenth century the fresco had badly deteriorated. It was first restored in 1726, but suffered badly during the French military occupation of the monastery from 1800 to 1815, when the room was used as a mess. Other restorations were not very satisfactory; the fresco was repainted in many parts and radically restored in 1953; it is now but a shadow of the original. In a better state of restoration are the three lunettes above the fresco representing the Sforza arms and garlands of flowers; these lunettes are often ascribed to pupils, but are in fact splendid examples of Leonardo's work. The commission was given to Leonardo by Lodovico il Moro about the year 1495.

48 Virgin and Child with St Anne and the infant St John. Cartoon, 139 × 101 cm. London, National Gallery. It was seen by the Abbot Resta in the collection of Count Arconati in Milan about the year 1696, then passed into the collection of the Marchese Casnedi, where it remained until 1722. It then went to the Sagredo collection in Venice, where it was bought by an English gentleman, Robert Udny, in 1763. In 1791 it became the property of the Royal Academy. The basic problem relating to this cartoon is whether it is the same work as the one described by Fra Piero da Novellara in a letter written on 8 April 1501 to the Marchesa Isabella d'Este referring to an altarpiece commissioned by the Serviti friars of Florence. However, in the detailed description given by the friar, there are numerous discrepancies between this cartoon and the one in London, as well as the carton in the Louvre, and these differences cannot be due to the writer's inexactitude because they radically affect the complex mystical symbolism of the work. The supposed weakness of execution found in some parts of the Paris cartoon has led some historians, including Golscheider, to adopt an extremely complex, but fairly plausible solution. The London cartoon may have been for a first version of the subject, painted in Milan and now lost; no trace remains of the Florentine work, apart from a copy, possibly by Brescianino, in the reserve collection of the Staatliche Museen, Berlin. The version now in the Louvre (*pls. 49-51*) would have been drawn during Leonardo's second stay in Milan.

49-51 Virgin and Child with St Anne and the infant St John. Oil on panel, 170 × 129 cm. Paris, Louvre, No. 1598. See the above explanation for the origins of this work. Some historians, partly because of the poor state of preservation of this work, attribute much of the execution to pupils in Milan. The work was seen in Leonardo's studio in 1517 by Cardinal Luigi d'Aragona. It was taken to Paris by Leonardo and brought back to Italy by Melzi together with the other works left by Leonardo; it was bought from Casale by Richelieu in 1629 and has been in the Louvre since 1801.

52-55 Mona Lisa. Oil on panel, 77 × 53 cm. Paris, Louvre. No. 1601. The surface of the painting is badly damaged; much over-painting has been done on the dress, the veil and the hands; oxidation of the colours has produced an effect of monotony over the surface

of the painting; according to Woelfflin, the dress was originally green and the sleeves yellow. The history of this painting is well known. It rapidly became the most famous work of art in the world and a constant place of pilgrimage; stolen in 1911 and found again two years later, imprudently sent to America in 1963, the *Mona Lisa* has become, in addition to the masterpiece it of course is, a religious, sexual and philosophical symbol. It is surrounded by a mass of suppositions which nearly always not only violate the historical significance of the work, but ignore even the most indisputable documentary evidence. The identification of the subject with Monna Lisa del Giocondo has been doubted, in spite of the testimony of Vasari and undeniable documentary proof; and even its authenticity has not always been accepted. The most amazing thing is that this whole pseudo-problem is already present in the writings of Vasari, from the ' magical ' elements to the birth of the myth of the smile.

Leda (illustrated in black and white). Oil on panel, 114 × 86 cm. Rome, Gallotti Spiridon Collection. It formed part of the De Ruble Collection in Paris. Among Leonardo's lost works, his *Leda* is particularly important, and not only for the exceptional quality of the copy which remains. For the ' invention ' of this work there are a series of studies in existence, which show how it followed a structure which remained a model for the whole sixteenth century, even through variations created by Michelangelo. Its fame was exceptional and immediate: a drawing by Raphael in 1504 (Windsor, Royal Collection, No. 12337) is the most famous echo, and mention should also be made of the beautiful *Leda* produced by the school of Del Sarto about the year 1510 and now in Brussels, the three versions of the painting produced by Bacchiacca, and finally the version by Pontormo in the Uffizi. It was not mentioned by Vasari, but by the Anonimo Magliabechiano. It probably went to Fontainebleau, where it was seen by Lomazzo in 1584 and by Cassiano del Pozzo in 1625. Cassiano's description would seem to correspond to the Spiridon *Leda*, especially in the detail of the panel formed by three plaques placed together longitudinally (' *per lo lungo* '). In spite of the superb quality of the execution, it is unlikely that the Spiridon *Leda* is by Leonardo's own hand; it is even extremely doubtful whether this work is a copy of the Florentine prototype. Since there is no exact description of this original, there are grounds for believing that it was based on a cartoon which, according to Wright (1730), was in the Casnedi collection, Milan. This collection, which also included the *St Anne* now in London, contained some of the works left by Leonardo to Melzi on his death. It might therefore be supposed that Leonardo drew the cartoon for the Spiridon *Leda* and left the execution of the painting to his pupils. These pupils would have been Florentine rather than Milanese, for although it has been widely believed that Melzi was responsible for the execution of this *Leda*, the style and manner of painting belong directly to the Florentine cultural milieu of the late period of Piero di Cosimo which produced Franciabigio, Andrea del Sarto and Bacchiacca.

56 St John the Baptist. Oil on panel, 69 × 57 cm. Paris, Louvre, No. 1597. Executed by Leonardo about the year 1517 and brought by him to France. It belonged to Francis I, then was given to Charles I of England by Louis XIII in exchange for a painting by Holbein and one by Titian. It was bought back in 1649 on behalf of Cardinal Mazarin, from whose collection it passed to that of Louis XIV. This is almost certainly the last oil painting done by Leonardo and certainly the latest known to us; it represents the extreme consequences of his ideas concerning light-mass relationships.

57 Self-Portrait (?). Sanguine on paper, 33.3 × 21.4 cm. Turin, Biblioteca Nazionale. The question of the identity of the sitter is extremely debatable. We have no direct evidence that this is a self-portrait, and tradition has always referred to what is perhaps the most likely source, that is the profile in the wood-engravings illustrating Vasari's *Lives* which corresponds to the portrait painted by Vasari himself in the fresco *Leo X and his Cardinals* in the Palazzo Vecchio. The face painted by Vasari resembles one which often appears in the drawings of Leonardo, both in studies of human proportions, when it is unbearded, and in this Turin portrait. This heavily-bearded face as a prototype found again in two works by Raphael (Plato in the *School of Athens* and King David in the *Disputation*) and in a drawing of Michelangelo (*Man examining a Skull*, British Museum).

58 Drapery Study. Ink with white lead on coloured paper, 21.3 × 15.2 cm. Windsor, Royal Collection, No. 12521. Variously believed to be a study for the Uffizi *Baptism* (Seidlitz and Popham), the Uffizi *Annunciation* (Venturi), the *Virgin of the Rocks* (Clark and Bodmer), and for the Uffizi *Adoration* (Goldscheider).

59 Drapery Study. Red pencil on coloured paper, pointed with white lead, 24.3 × 19.4 cm. Rome, Galleria Corsi, No. 125770. Popp thought it a study for the Louvre *Annunciation*, while Goldscheider thought it was either for the Uffizi *Adoration of the Magi* or a lost *Annunciation*. It belongs to Leonardo's first Florentine period.

60 Rocky Landscape with swans. Pen on paper, 22 × 15.8 cm. Windsor, Royal Collection, No. 12395. Popp and Bodmer date it 1481-83; Clark and Goldscheider, 1475-78.

61 Head of a Lady. Silverpoint pencil on paper, 16.5 × 12.4 cm. Windsor, Royal Collection, No. 12512.

62 Profile of a Lady. Bistre on brown cardboard, pricked for transfer, 45 × 59 cm. Paris, Louvre, M.I. 753. This is probably all that remains of a portrait of Isabella d'Este which, according to documentary evidence, was executed by Leonardo in 1500. The pin-pricking indicates that the final portrait was later done by a pupil. This cartoon is in a very poor condition and has been

retouched by pupils and by later restorers; it has been the prototype for numerous drawings and school works (Uffizi, British Museum, Oxford, etc.).

63 Warrior. London, British Museum, Nos 1895, 9, 15, 474. Certain historians have ascribed this to Verrocchio, but it is certainly by Leonardo, and a typical theme of Florentine sculpture. Datable to around 1478.

64 Five caricature heads. Pen and ink on paper, 12.3 × 18 cm. Venice, Accademia. This is one of the studies of faces in which Leonardo examined possible variations on the human physiognomy, either through the character of the subject, or through resemblances to animals.

65 Caricature profile of a youth in a beret. Pen on paper, 18 × 15.5 cm. Paris, Cabinet des Dessins. Some historians (notably Sirèn) attribute it to Boltraffio. It is one of Leonardo's most ' finished ' drawings.

66 Study of horses. Silverpoint pencil on blue paper, Windsor, Royal Collection, No. 12321. Probably for the Sforza Monument, therefore datable to about 1490-91. This is the opinion of Clark.

67 Study of a horse. Silverpoint on blue paper. Windsor, Royal Collection, No. 12290. See note to *pl. 66.*

68 Battle study. Pen on paper, 14 × 10.2 cm. Venice, Accademia, No. 215. This is a sketch for the *Battle of Anghiari* and, together with the preceding drawing, probably refers to the central part of the work.

69 Battle study. Ink on paper, 15.5 × 14.3 cm. Venice, Accademia, No. 215 A. Study for the *Battle of Anghiari* cartoon.

70-71 battle of horsemen. Black pencil and ink on paper, 43.5 × 56.5 cm. The Hague, Dutch Royal Collection. Copy by Rubens of the central part of the cartoon of the *Battle of Anghiari* by Leonardo. No complete testimony remains of this highly important work by Leonardo; the survival of this central part of the work through numerous copies has led certain historians to believe that this was the whole extent of Leonardo's idea for the fresco. We know that the original dimensions of the cartoon were enormous (8 × 20 m.) and that it is very likely that Leonardo took parts of it with him to France, so that this famous ' school for the whole world ', wich was exhibited for years with Michelangelo's cartoon in the Sala del Papa in the church of Santa Maria Novella, and copied by Raphael, Michelangelo and Andrea del Sarto, was only a large fragment of the original. This fragment, representing the battle around the standard, was executed by Leonardo in the Salone of the Palazzo Vecchio; it remained unfinished and deteriorated,

and in 1565 was covered over by Vasari's frescoes. The copy by Rubens was probably made in France from a section of the cartoon brought there by Leonardo himself.

72 Virgin and Child with St Anne. Pen on paper, 10 × 12 cm. Venice, Accademia, No. 230. Study for the *St Anne*, probably corresponding to the lost Florentine version described by Novellara and copied by Brescianino (see note to *pl. 48*).

73 Head of a Woman. Pencil with white lead and blue veil on reddish paper. 24.4 × 18.7 cm. Windsor Castle, Royal Collection, No. 12534. Probably retouched by an artist who was not one of Leonardo's *entourage*. According to Clark and Goldscheider, it is for the head of St Anne in the Florentine *Virgin and Child* cartoon mentioned by Novellara (see note to *pl. 48*). Every detail of this head may be referred to the Berlin copy of Leonardo's lost altarpiece, probably by Brescianino.

74 Study of a male head and architecture. Sanguine and pen on paper. 25.2 × 17.2 cm. Windsor, Royal Collection, No. 12552. Goldscheider believes this to be a study for the head of St James in the *Last Supper.*

75 Proportions of the human figure. Pen on paper, 34.3 × 24.5 cm. Venice, Accademia, No. 228. The drawing illustrates part of the first chapter of the third book of Vitruvius. This is the most famous of Leonardo's 'measurement' drawings, and the prototype of Luca Pacioli's work in this sphere.

76 Proportions of the human head and study of horses. Pen and ink on paper, 12.3 × 18 cm. Venice, Accademia. Datable to c. 1503. The study of horses is for the *Battle of Anghiari*, and this would indicate that the date is 1503 unless, as some historians believe, Leonardo worked on this at two different times.

77 Two profiles of men and ornaments. Pen on paper, 21.1 × 26.7 cm. Florence, Uffizi, Gabinetto dei disegni e stampe, No. 446. This drawing is particularly important, as it bears the inscription ' *bre 1478 inchominciai le 2 Vergini Marie* ' (' ...ber 1478 I began the 2 Virgin Marys '), as Leonardo's inventory which he made before leaving for Milan confirms. Some historians take this as an indication of the date of the *Benois Madonna* and the *Madonna with the Carnation,* although the latter was probably earlier).

78 Studies of war chariots. Ink on paper, 17.5 × 25 cm. London, British Museum, Nos 1880, 6, 16, 99.

79 Study of flowers. Silverpoint on paper, 20.2 × 18.5 cm. Venice, Accademia, No. 37.

80 Anatomical study. Pen and ink and black pencil on paper. 47 × 32.8 cm. Windsor, Royal Collection, No. 12281, *c.* 1513.

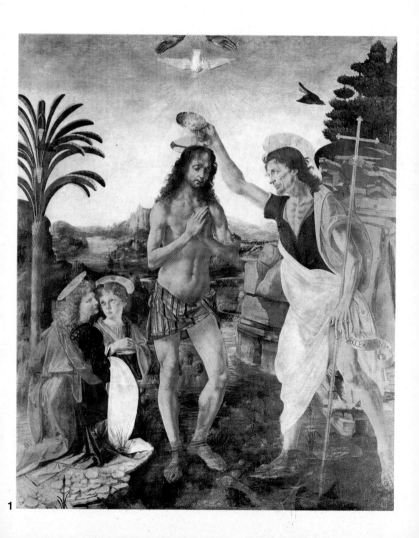

1

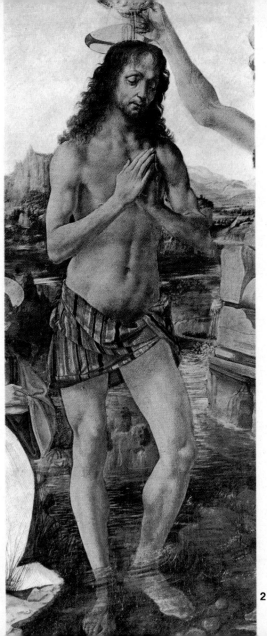

2

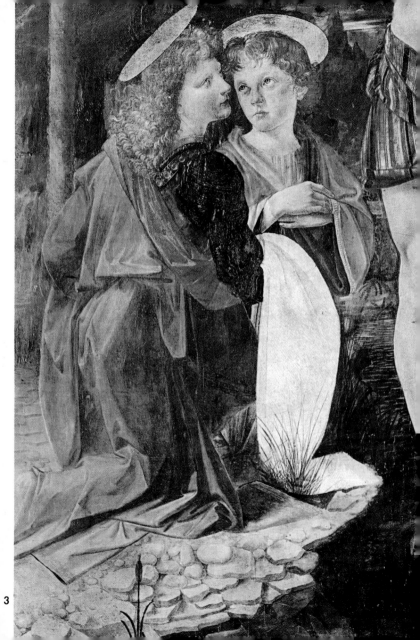

3

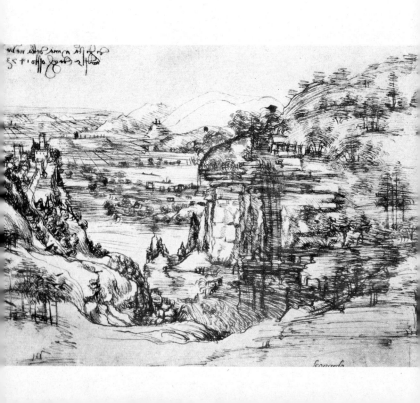

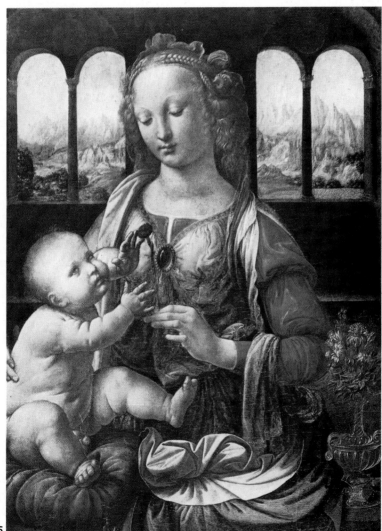

4

5

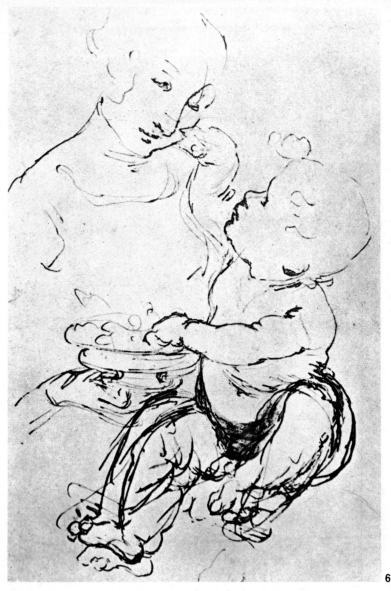

6

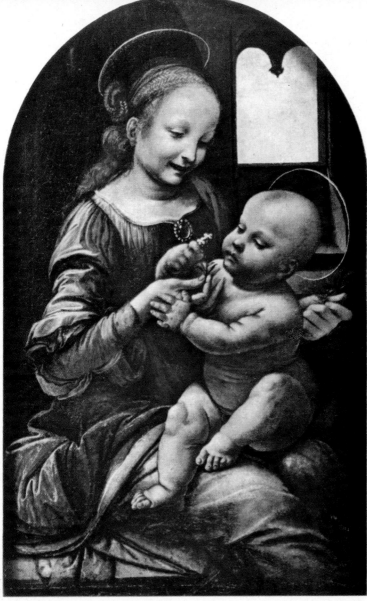

7

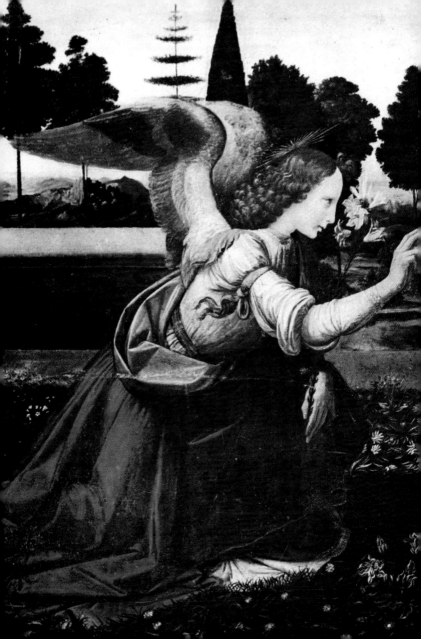

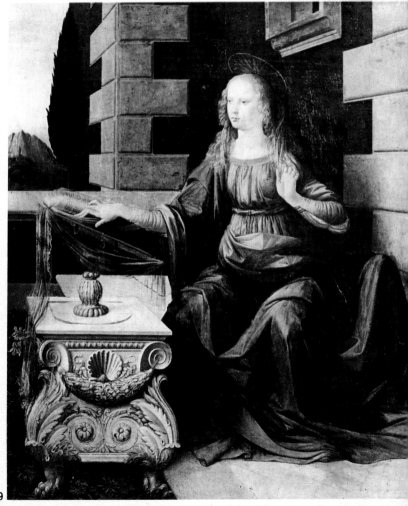

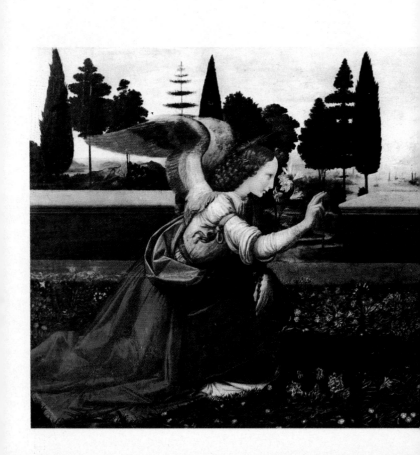

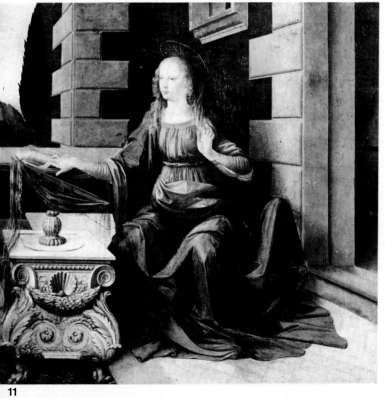

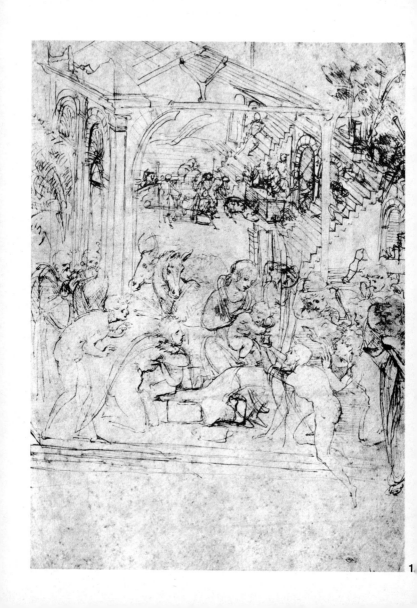

1

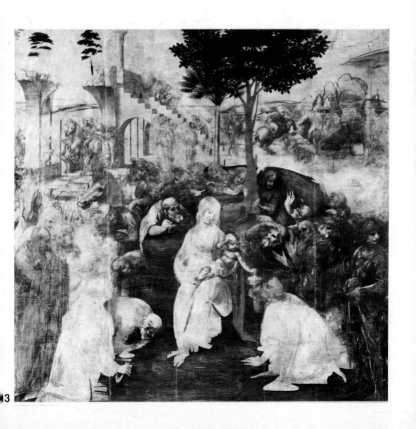

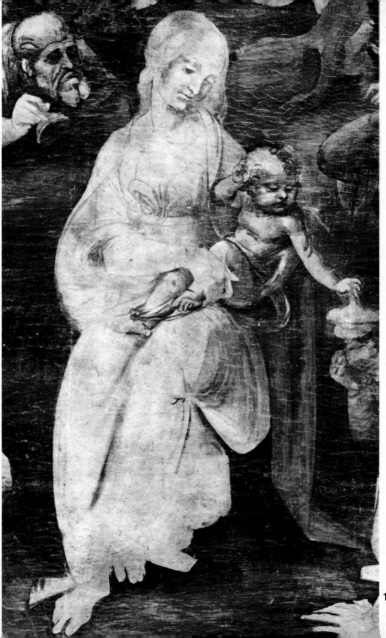

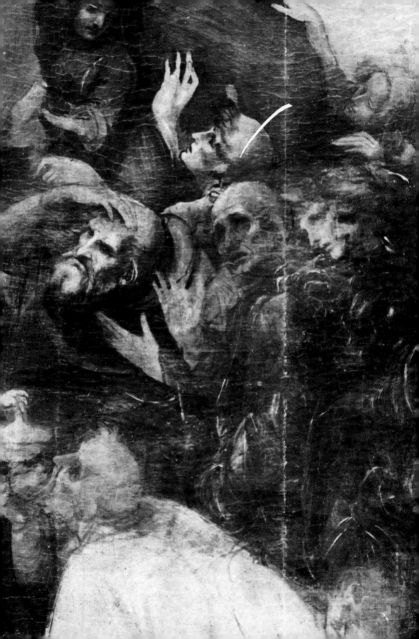

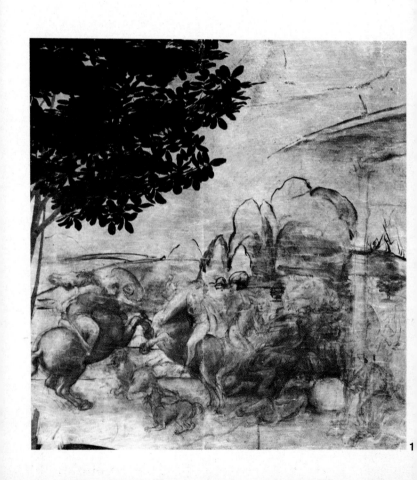

1

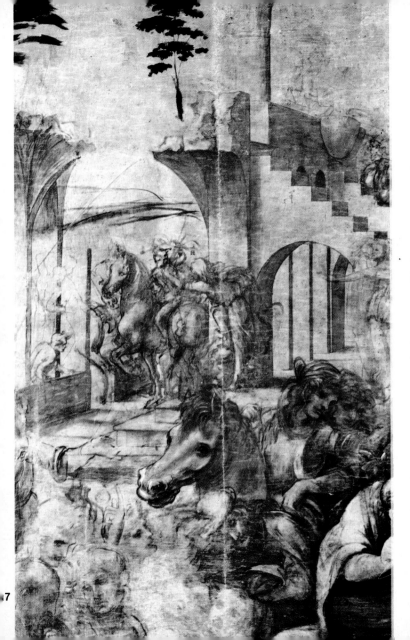

57

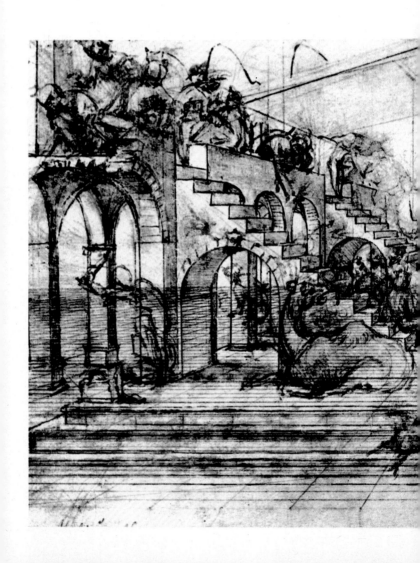

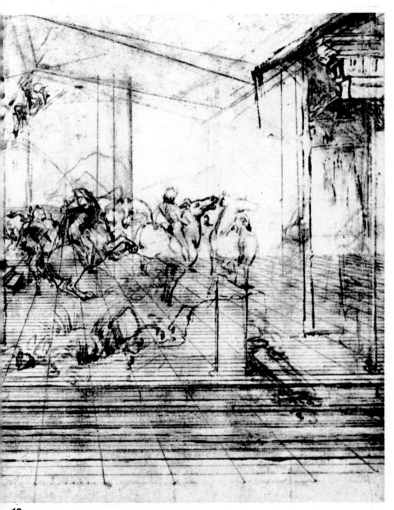

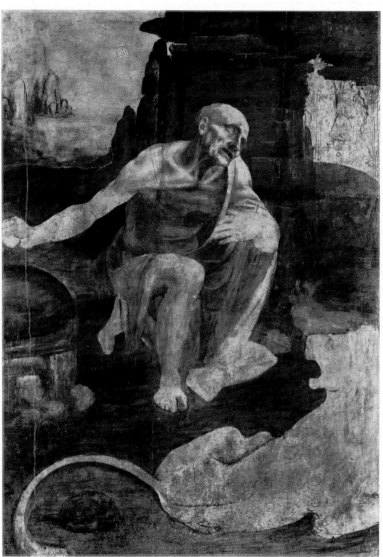

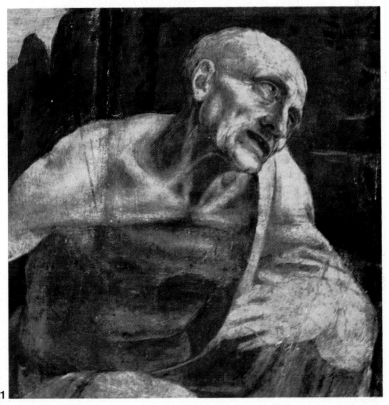

21

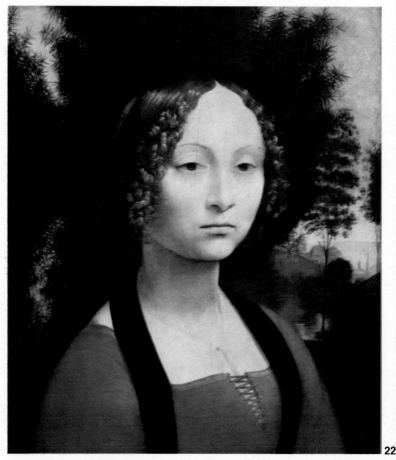

22

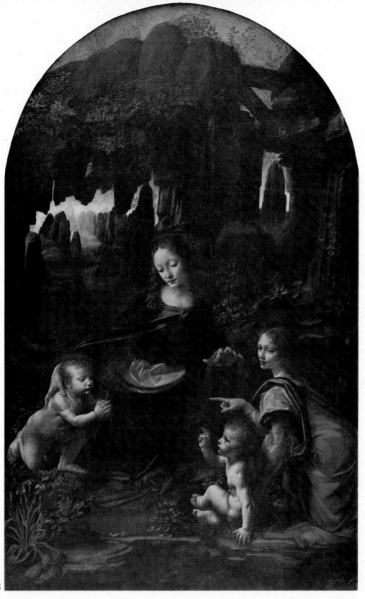

23

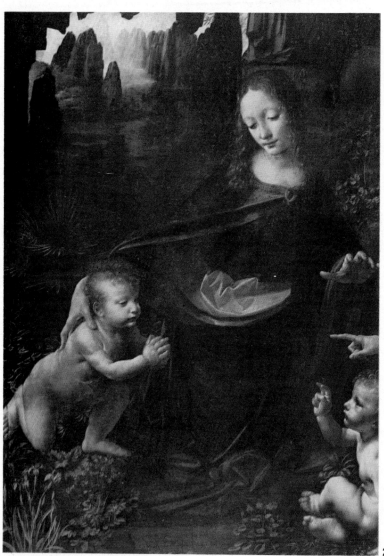

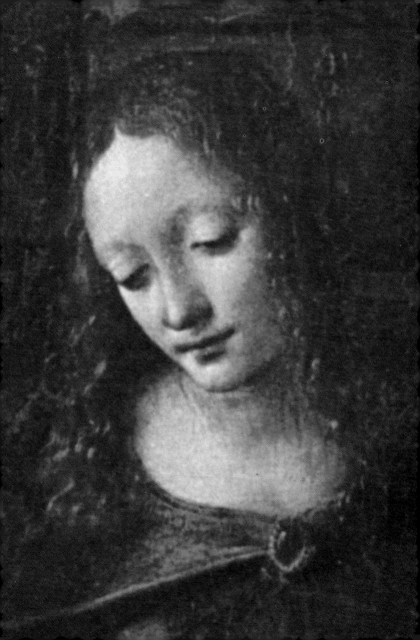

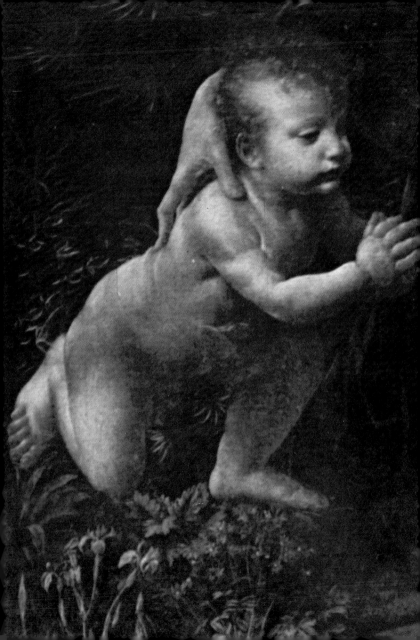

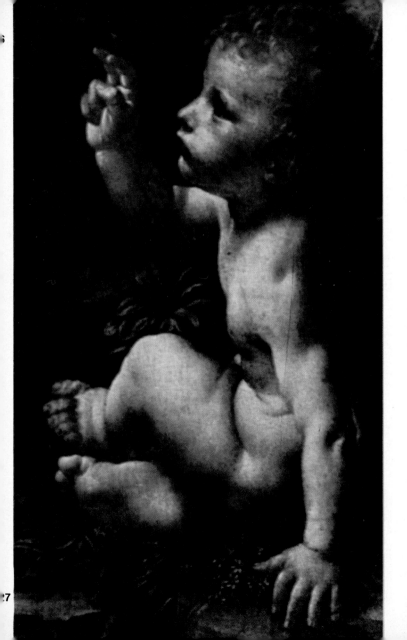

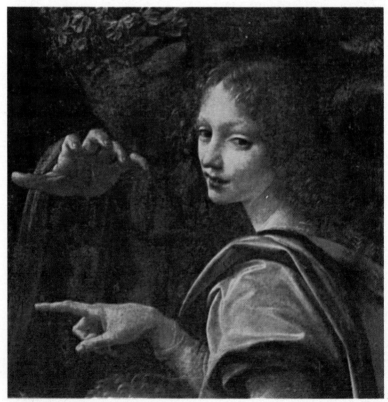

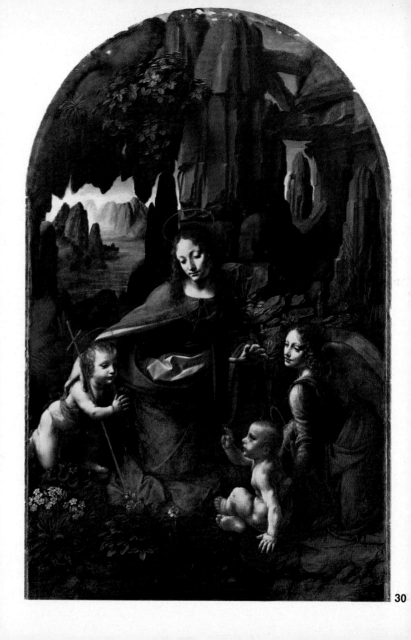

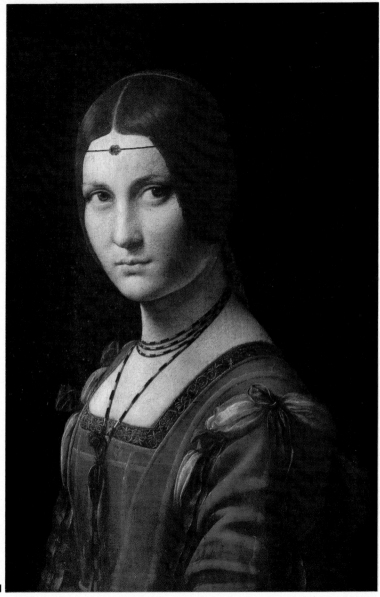

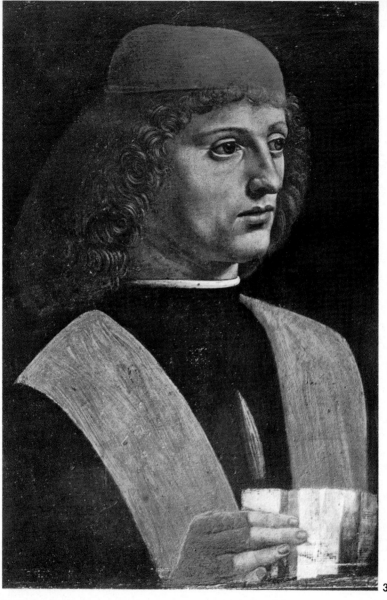

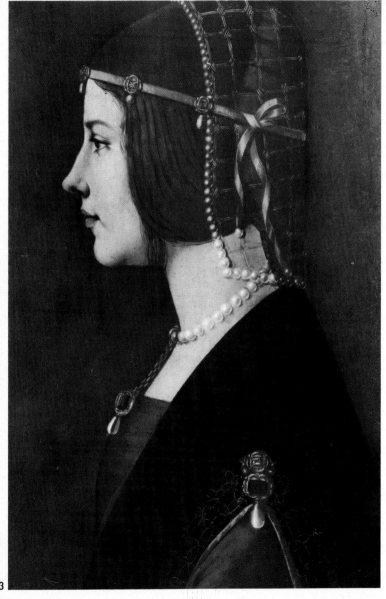

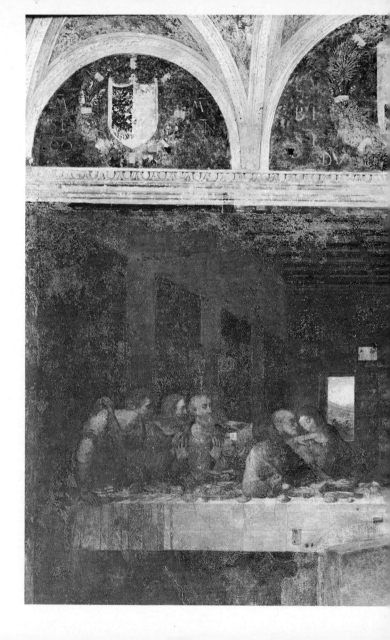

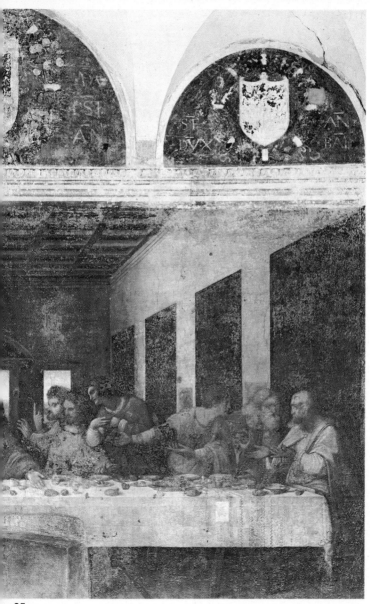

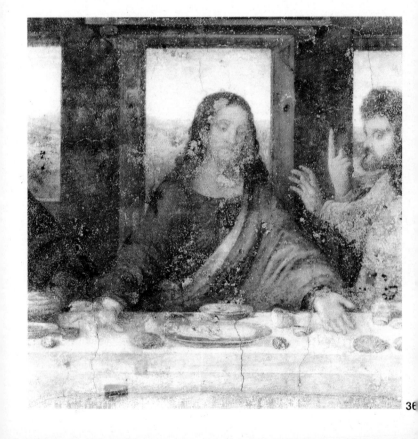

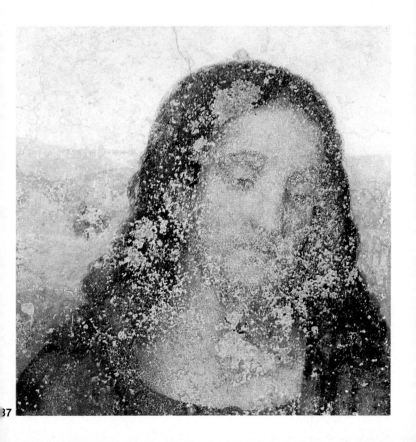

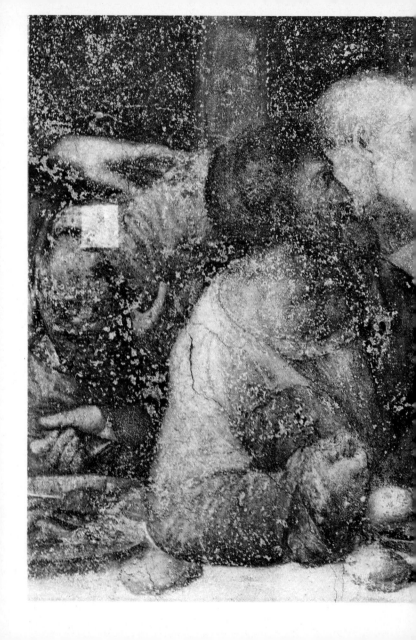

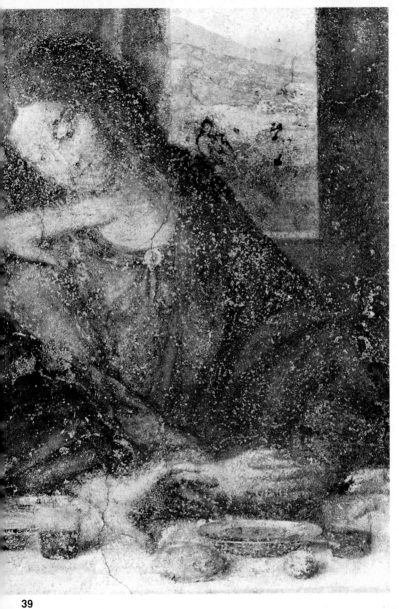

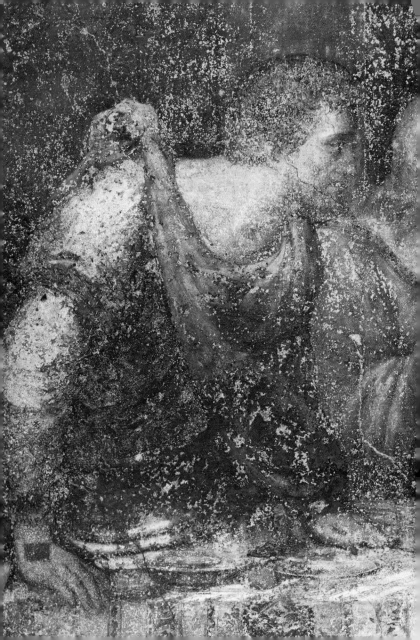

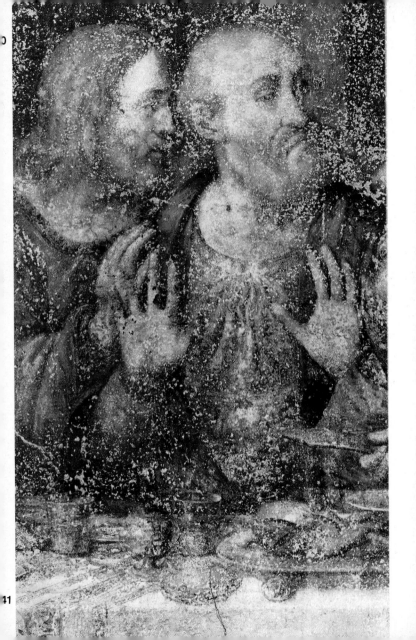

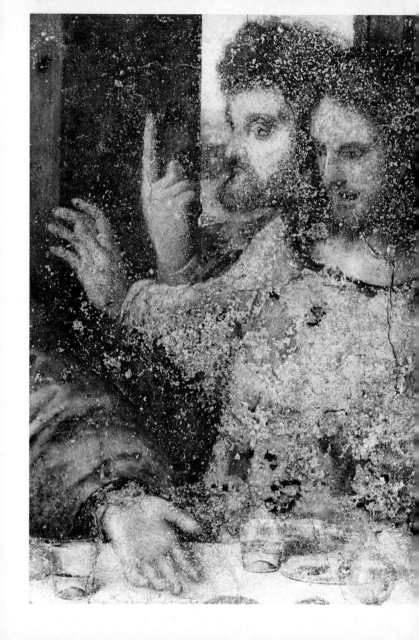

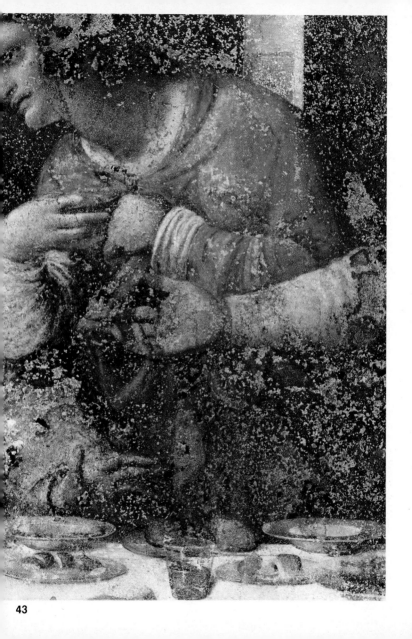

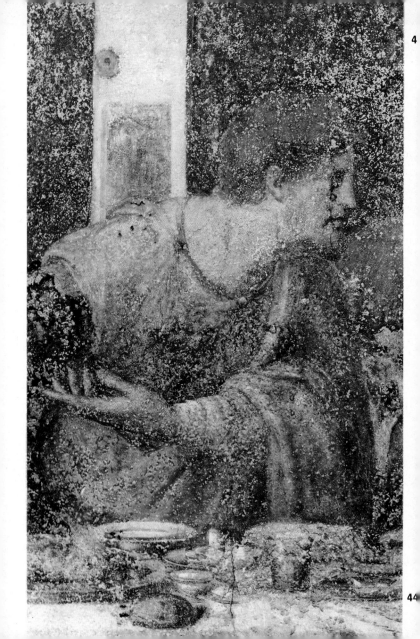

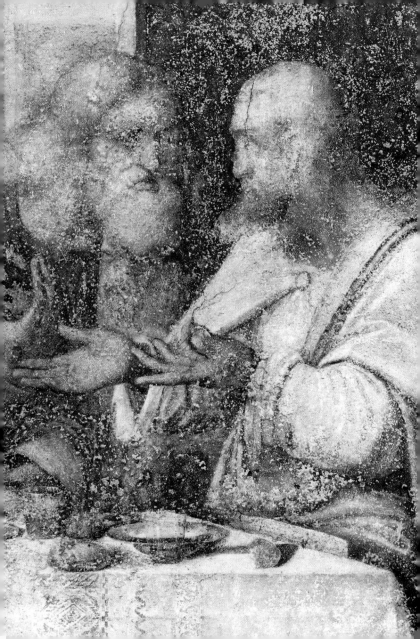

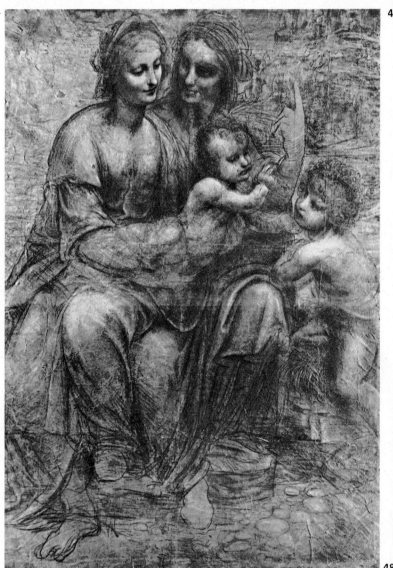

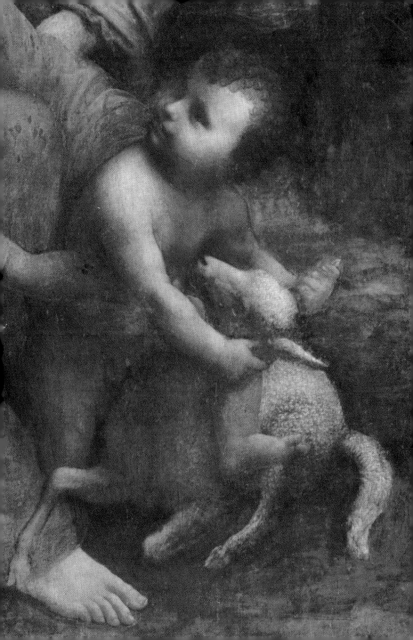

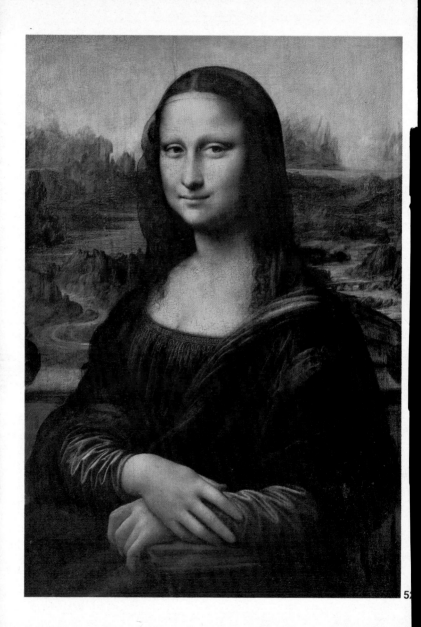

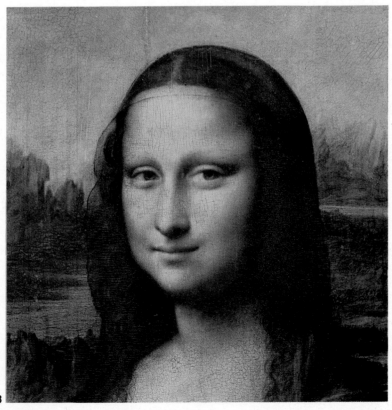

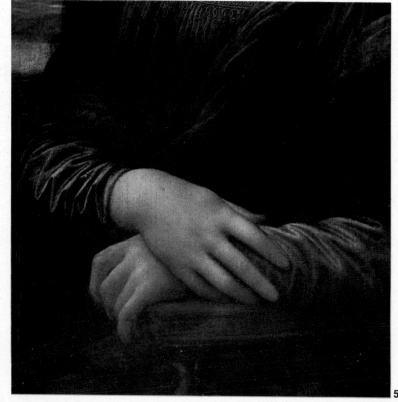

54

55

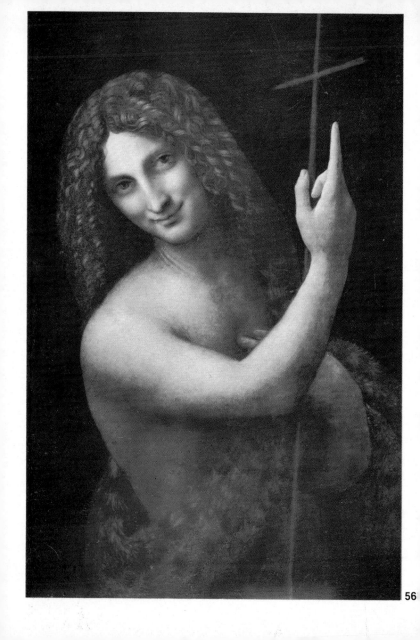

56

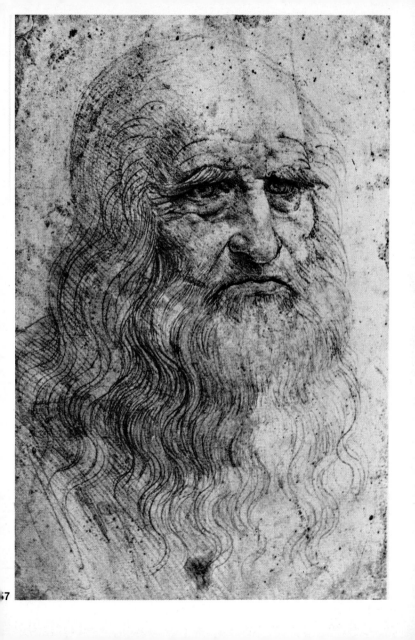

58

9

60

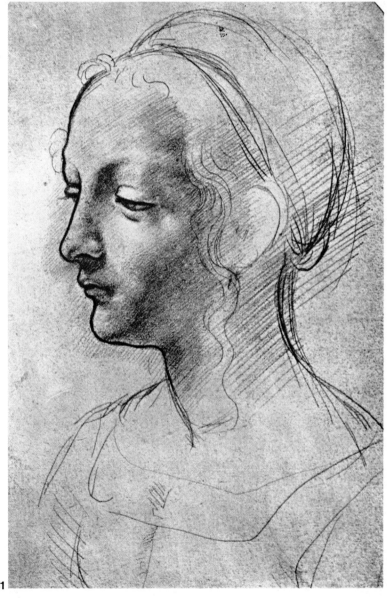

61

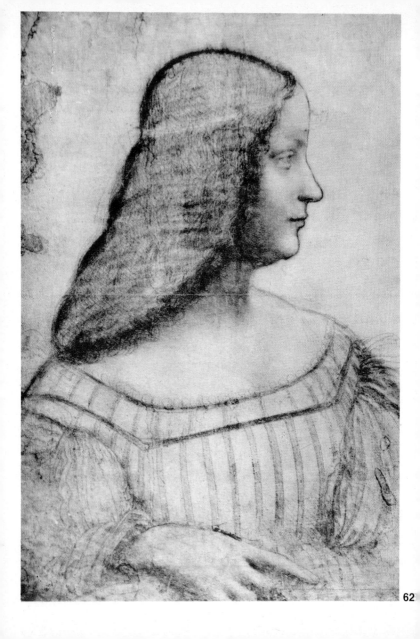

63

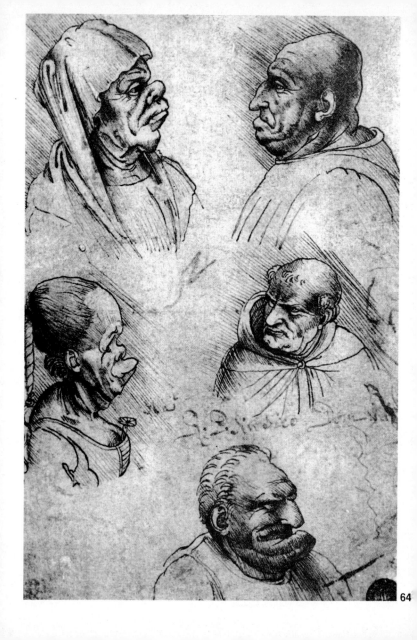

64

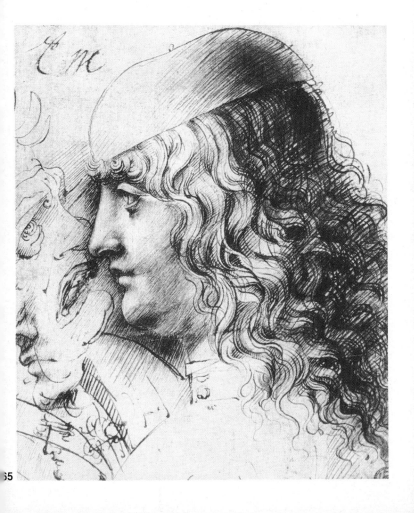

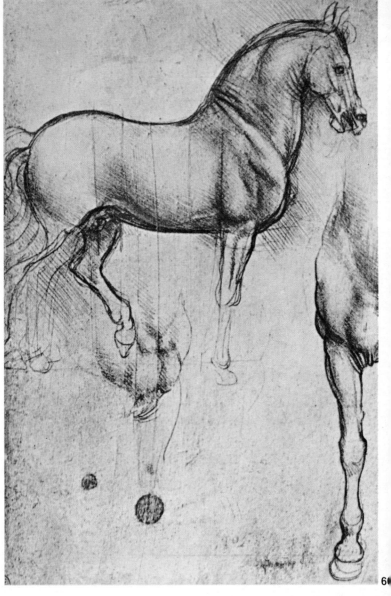

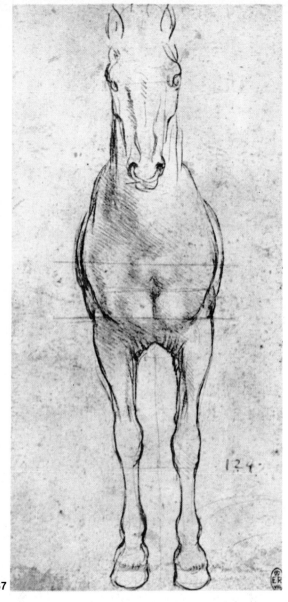

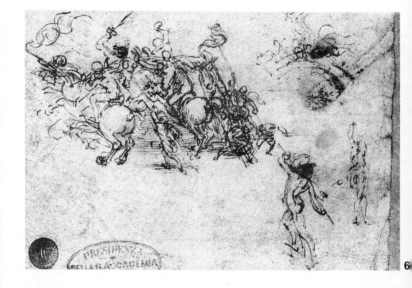

6

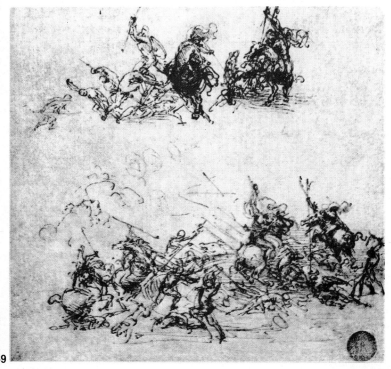

69

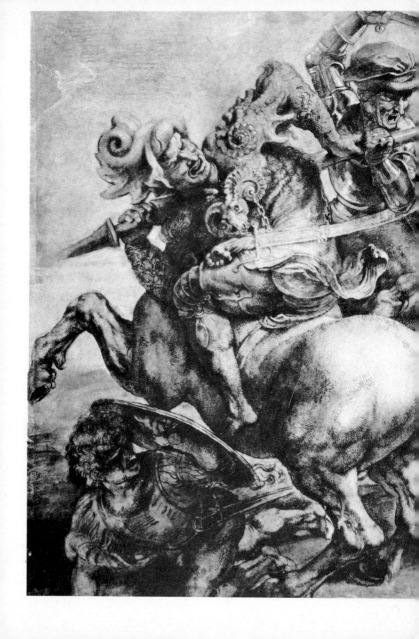

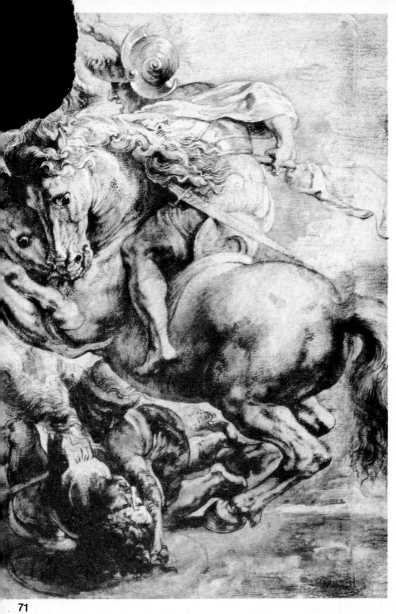

71

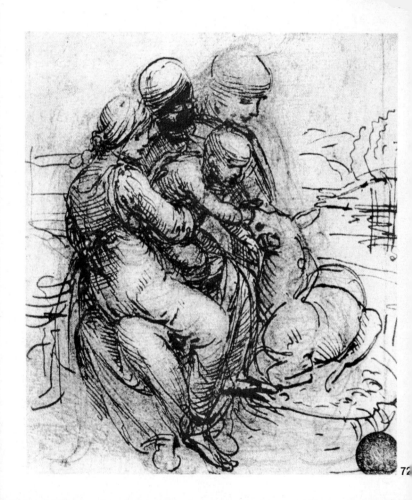

72

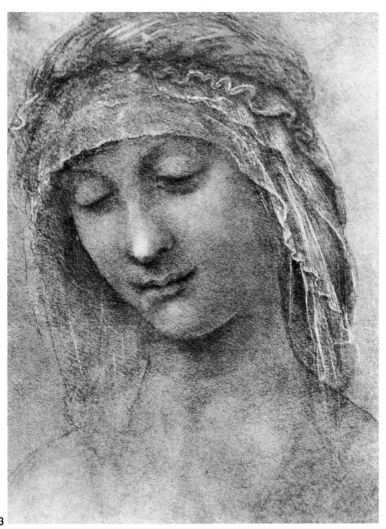

73

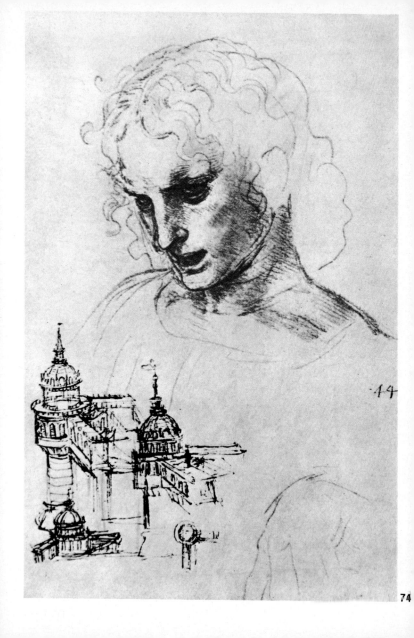

74

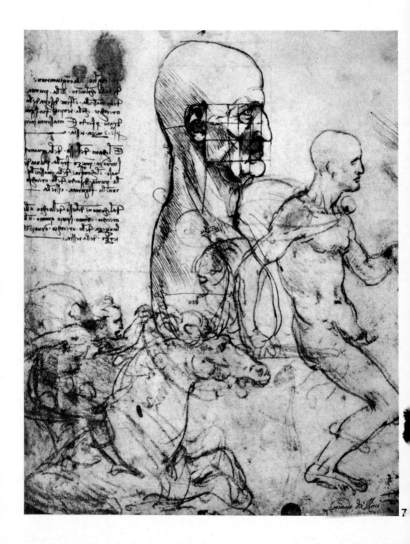

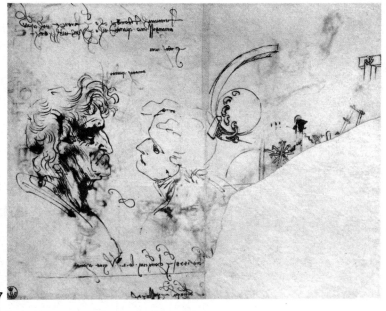

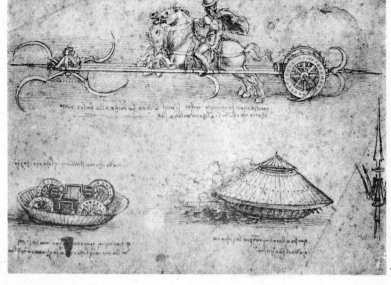

78

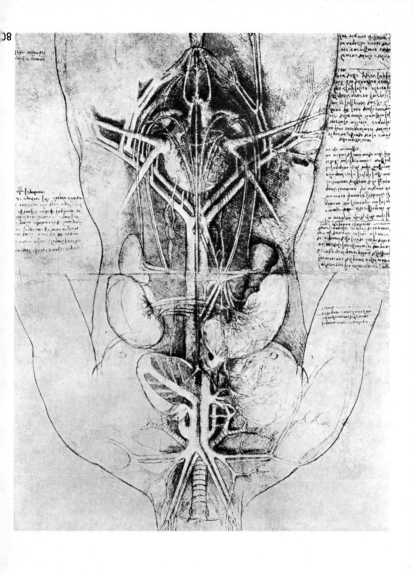

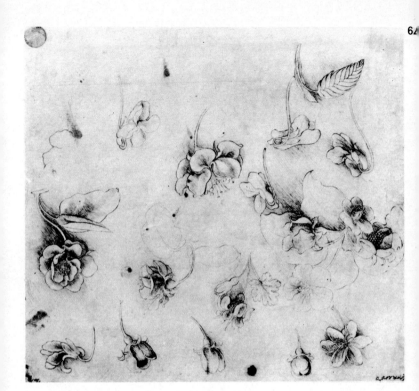